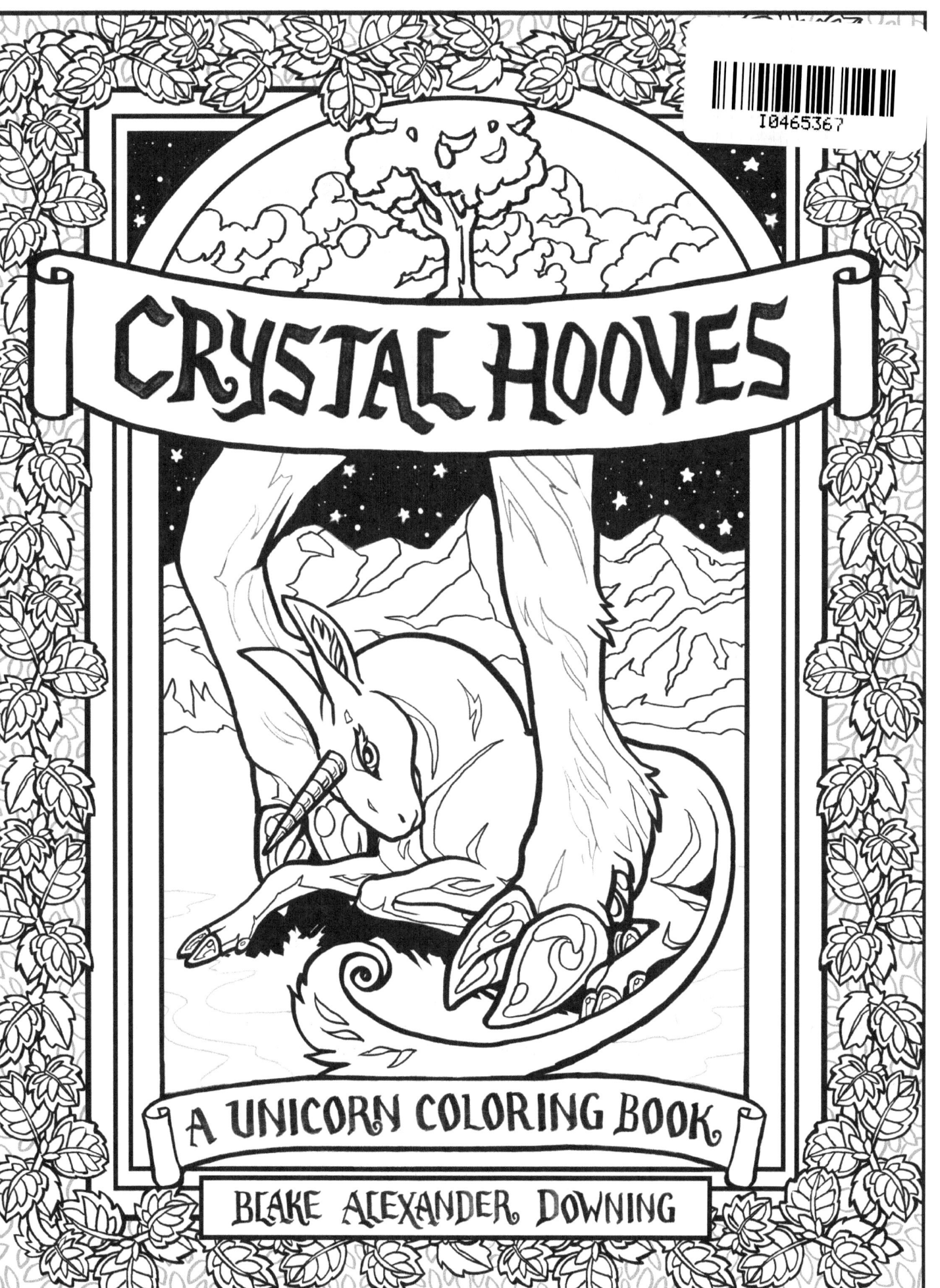

Crystal Hooves

A Unicorn Coloring Book

Copyright © 2017 Blake Alexander Downing. All rights reserved.

No part of this book may be reproduced, scanned or copied, except for your own personal use. You may share colored images on social media as long as the artist (Blake Alexander Downing) is credited. These images - colored or in their original state - may not be resold.

ISBN-13: 978-1979908795

ISBN-10: 1979908796

Hello!

I'm Blake Alexander Downing, an illustrator who draws and paints fantastic creatures and imagined landscapes inspired by dreams, stories, and fairytales.

As a symbol of kindness, positivity, peace, and possibility, it's no wonder that the mythical unicorn is well-loved by so many. Unicorns are indeed real, even if only because their impact on the world and the people in it is tangible. My life certainly wouldn't be the same without them.

I do my best to share this magic as much as possible through my art - here's hoping the pages within can bring you as much creativity, peace, and introspection as unicorns have given to me.

This is both an art book and a creative playground.

The drawings within are available for all personal use - you can add to them, cut them apart, use them in creative projects, give them as gifts - all as long as there is no commercial use. Basically, don't sell any part of the book for profit, and don't distribute uncolored pages online or offline.

However, you are most definitely allowed to post your colored pieces on social media! I do ask that you credit me - my name alone is fine.

The drawings are all printed on one side of the paper to account for bleed. However, I have also included some small repeating spot illustrations on the back of each page to keep them from being completely blank. If you're still worried about bleed, you can tuck a loose piece of paper underneath the page you are coloring to protect the following page.

There are a few blank pages at the end of this book so that you can test out your supplies, colors, and palettes.

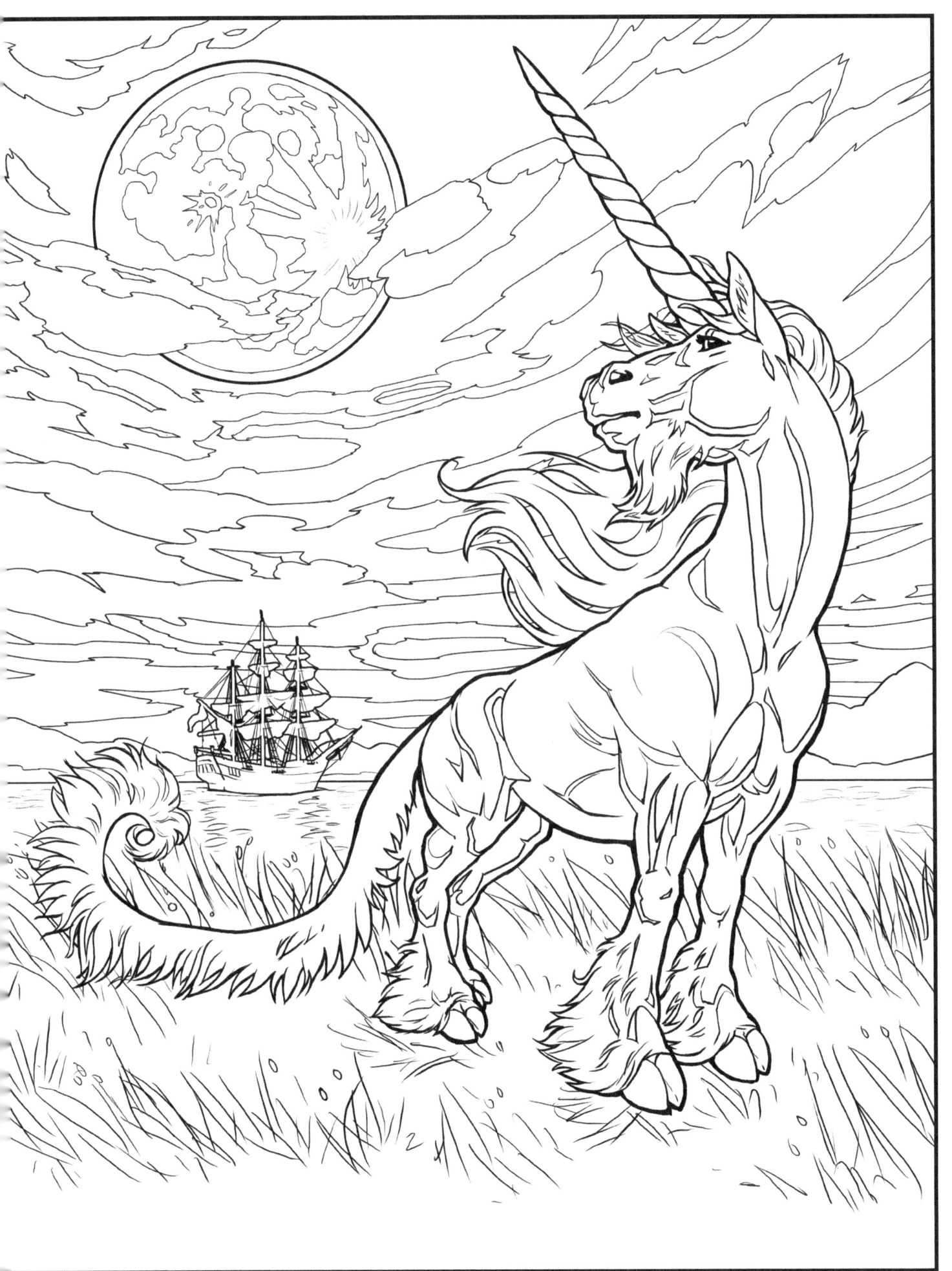

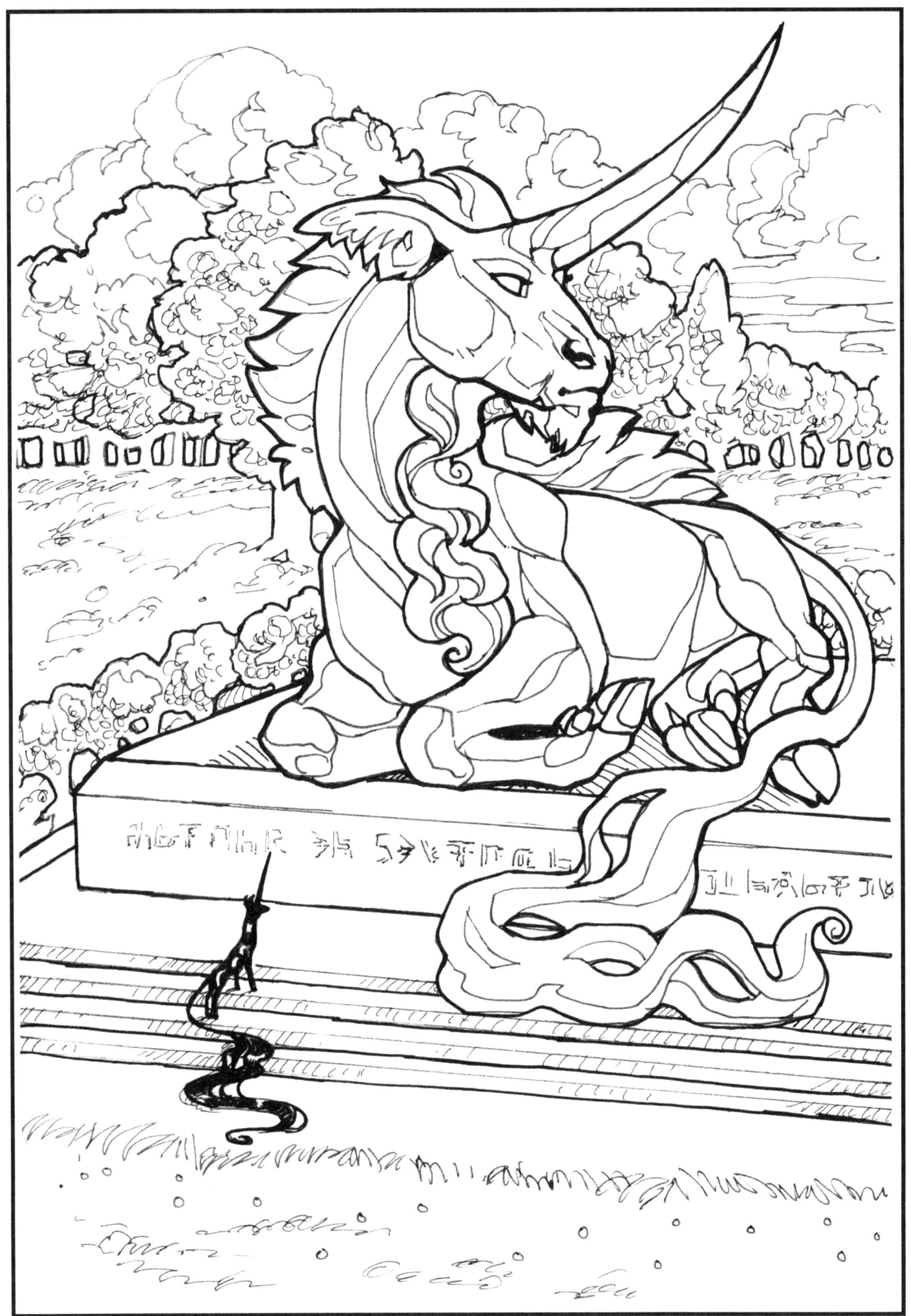

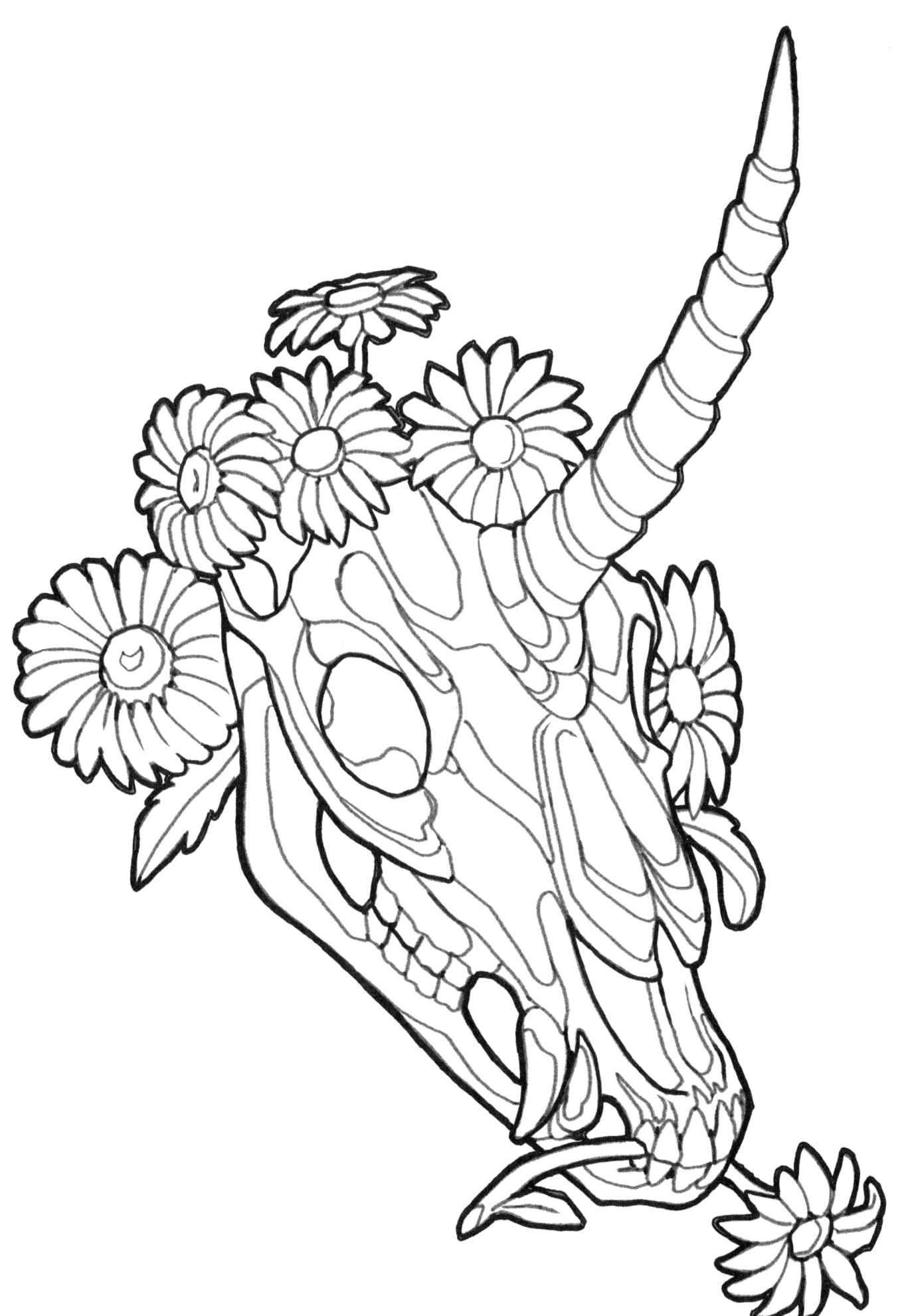

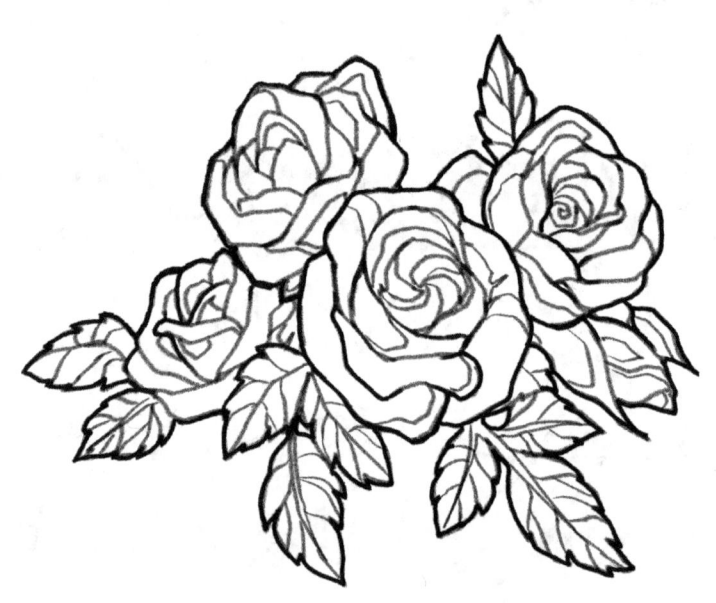

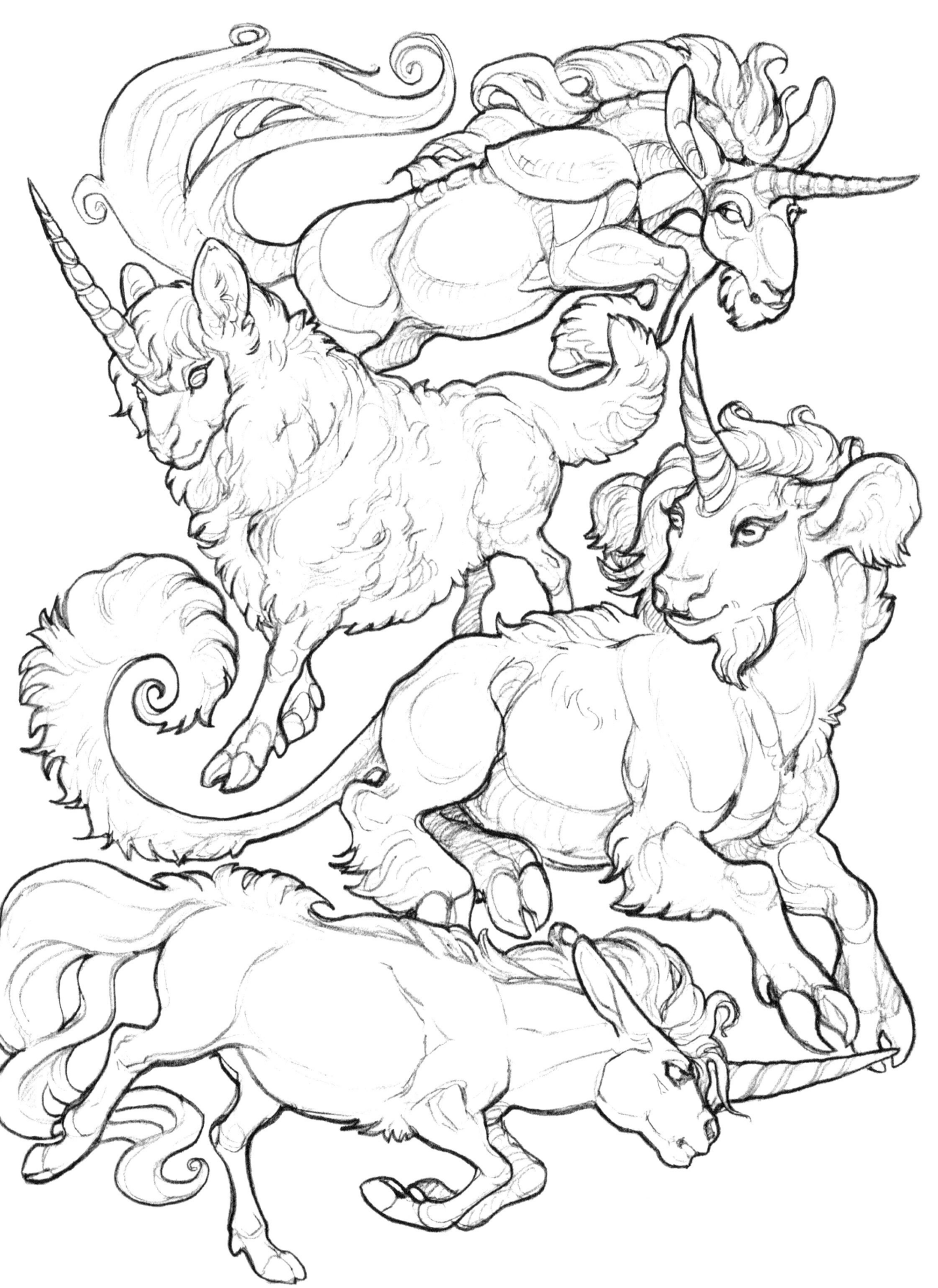

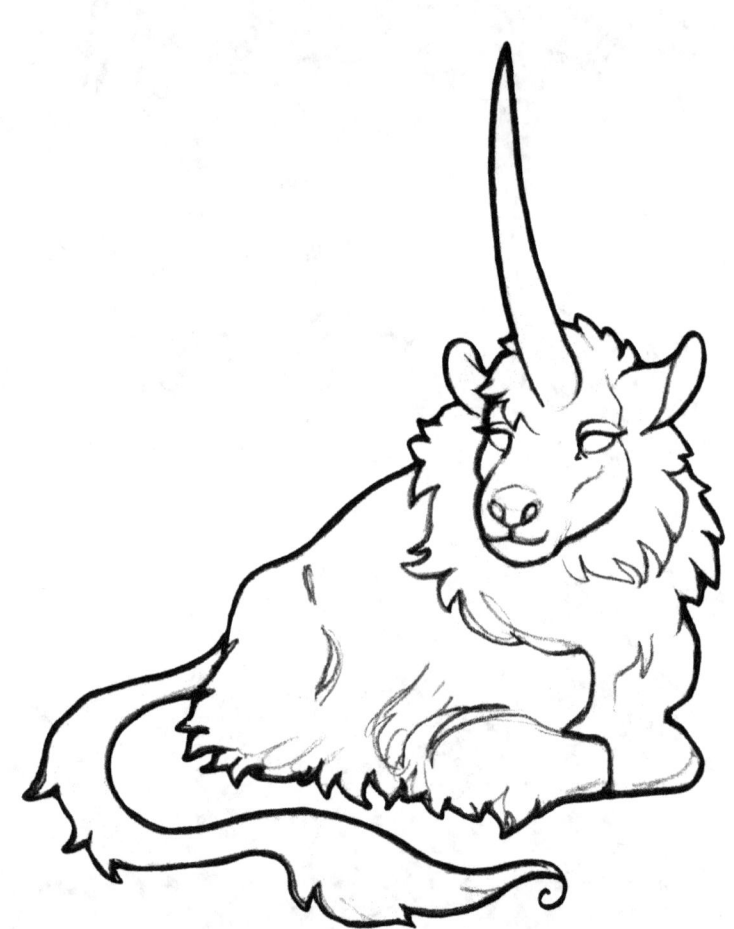

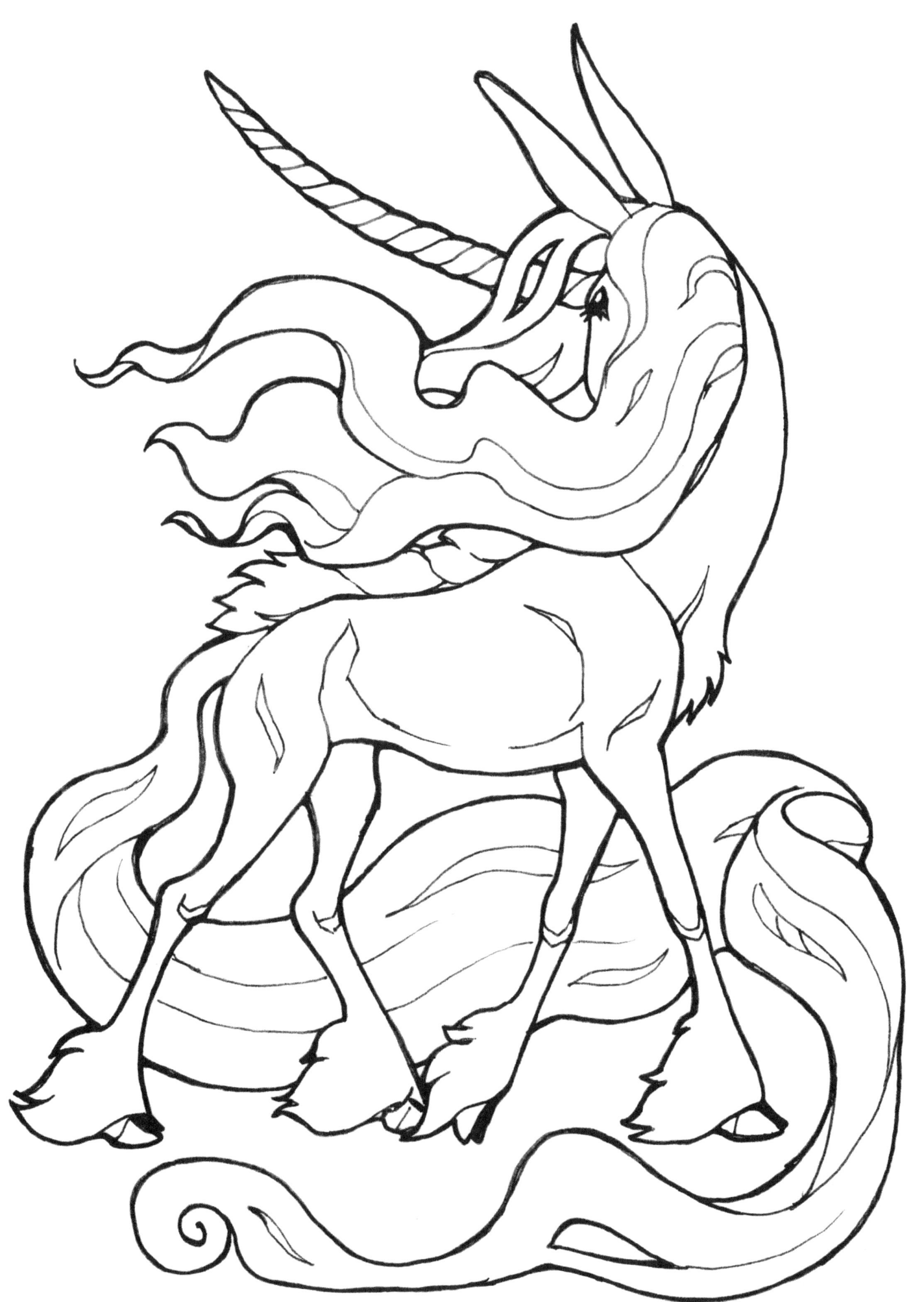

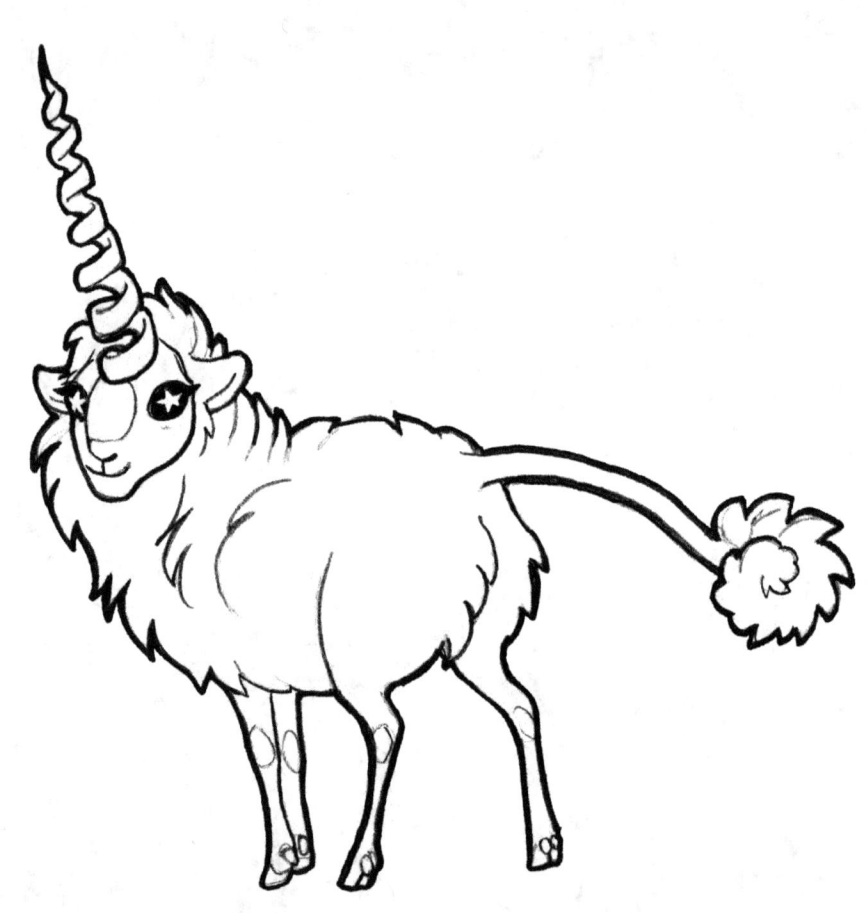

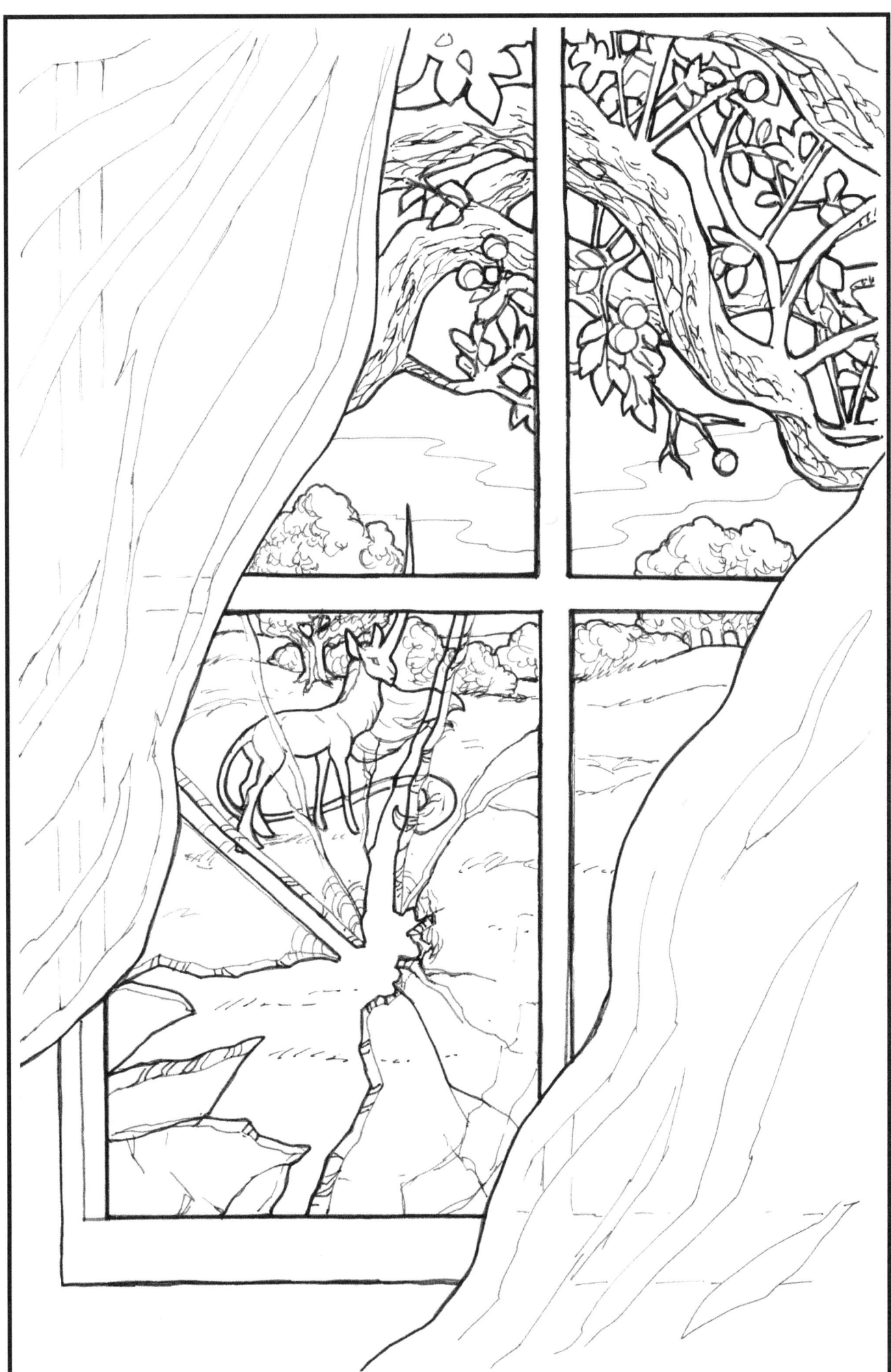

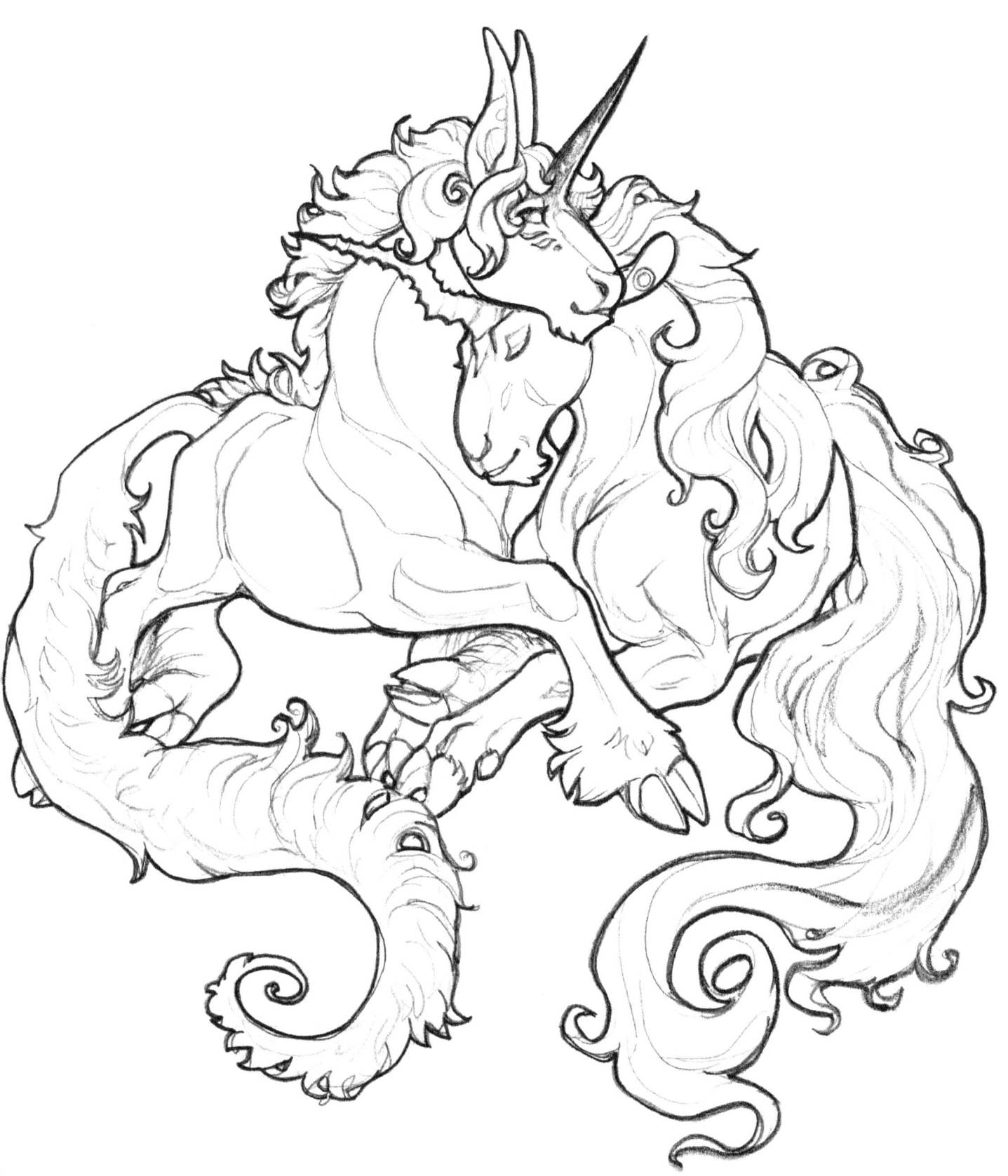

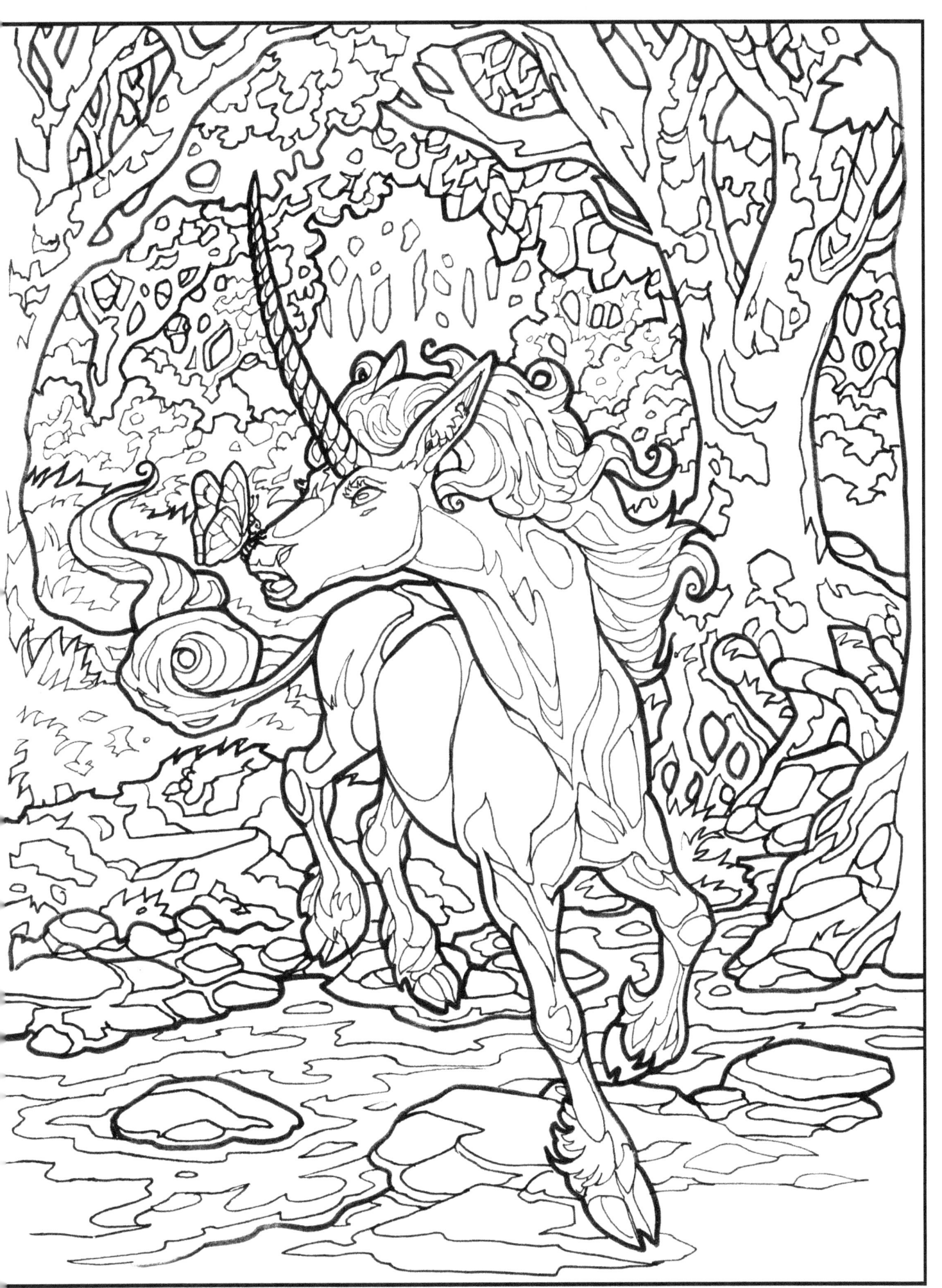

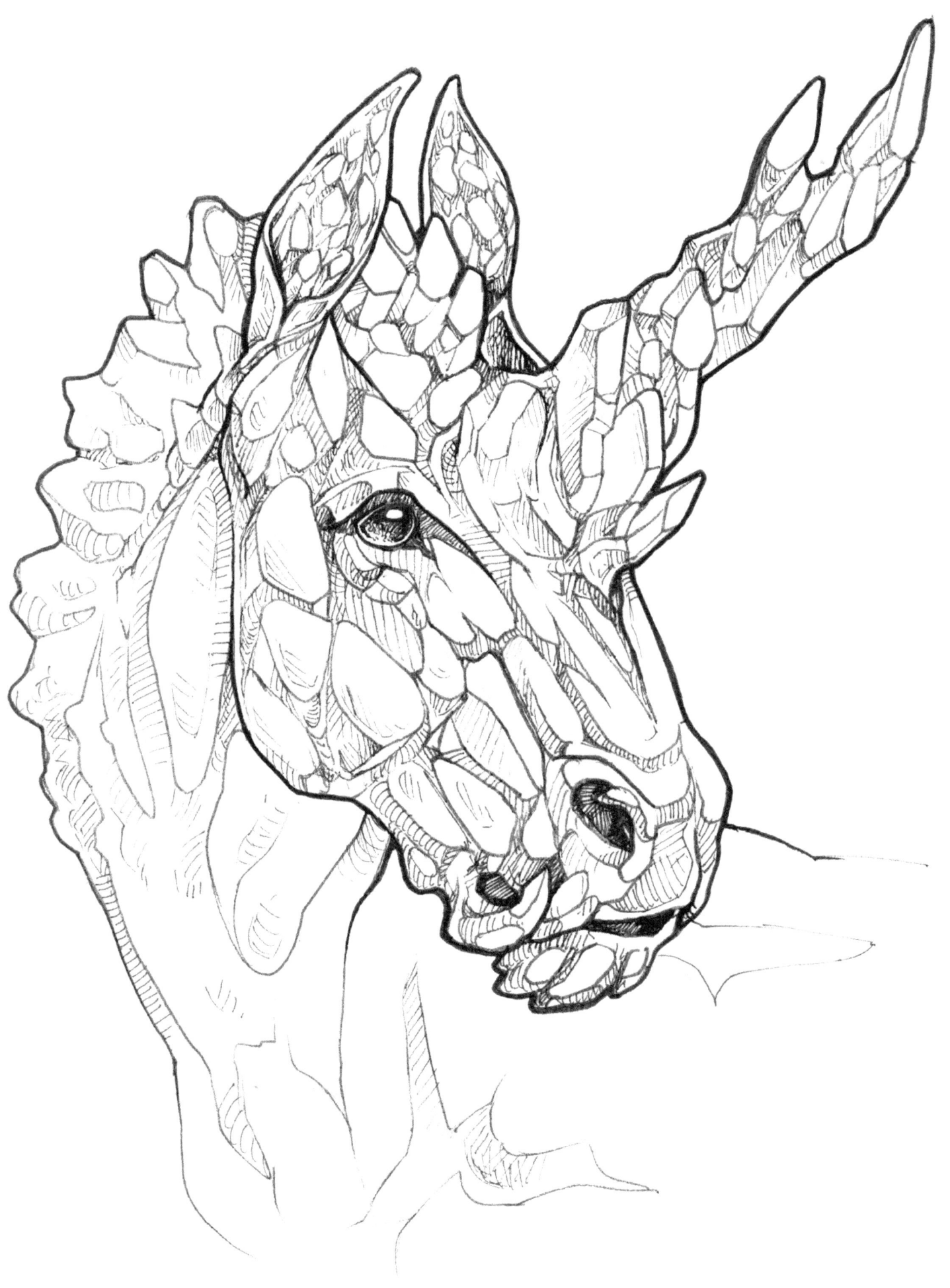

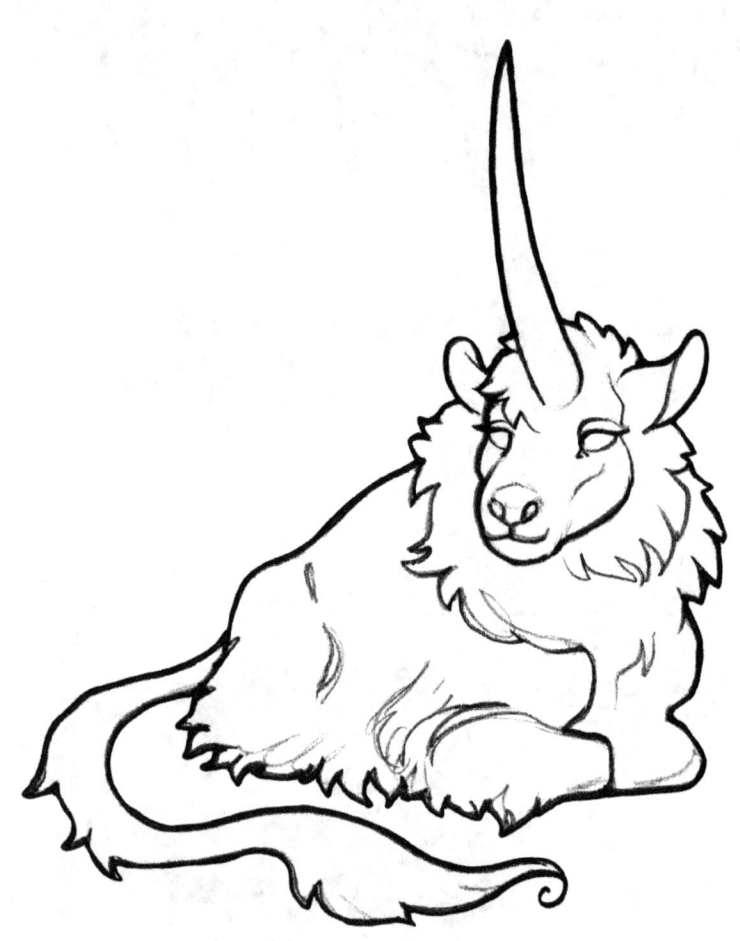

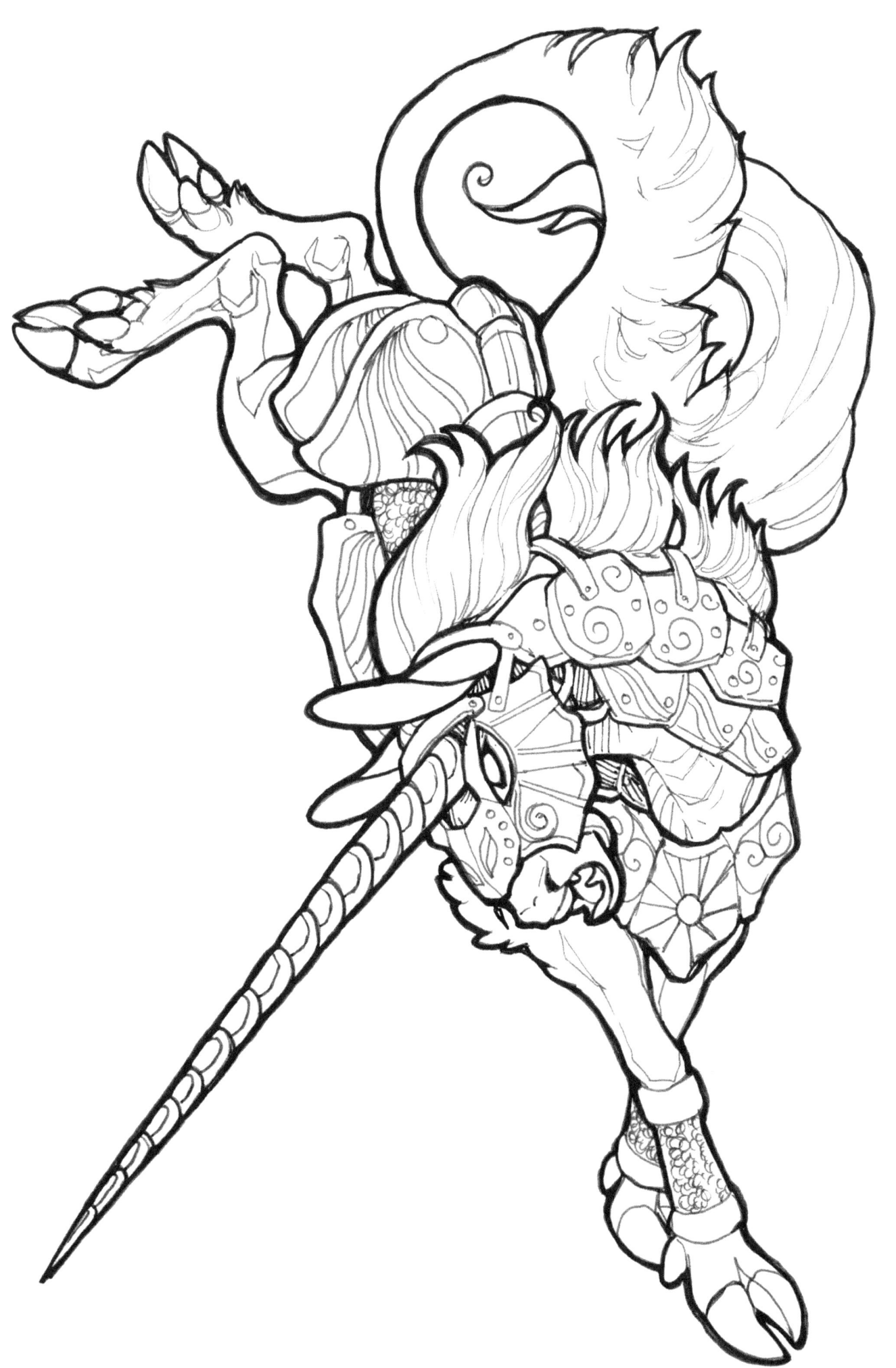

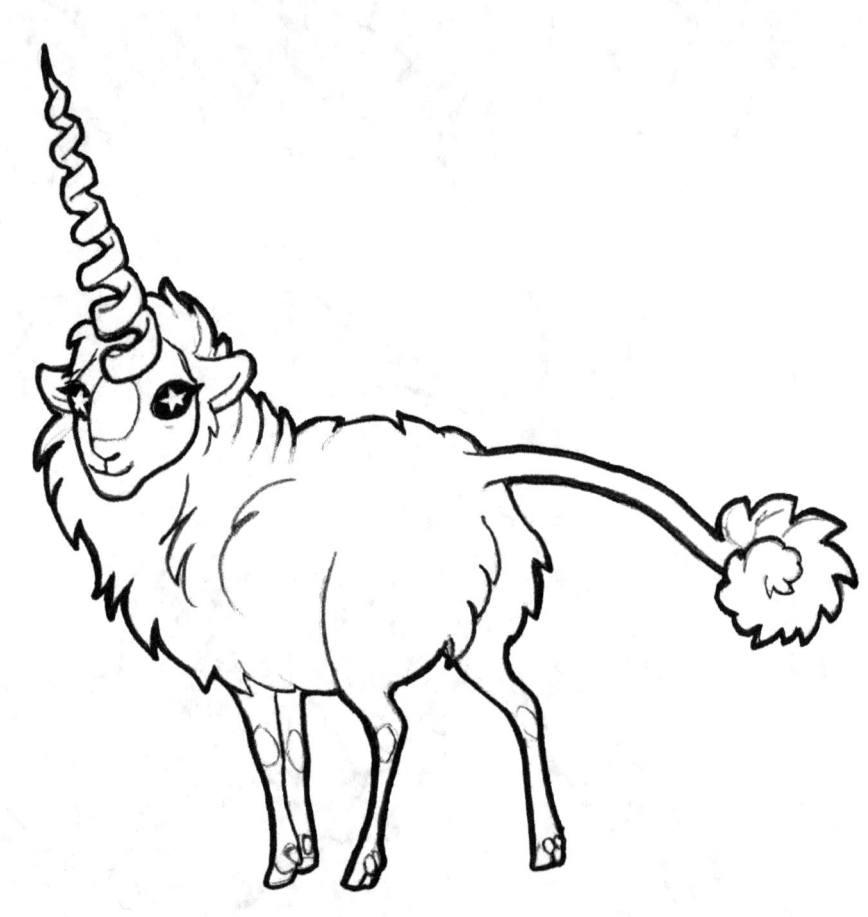

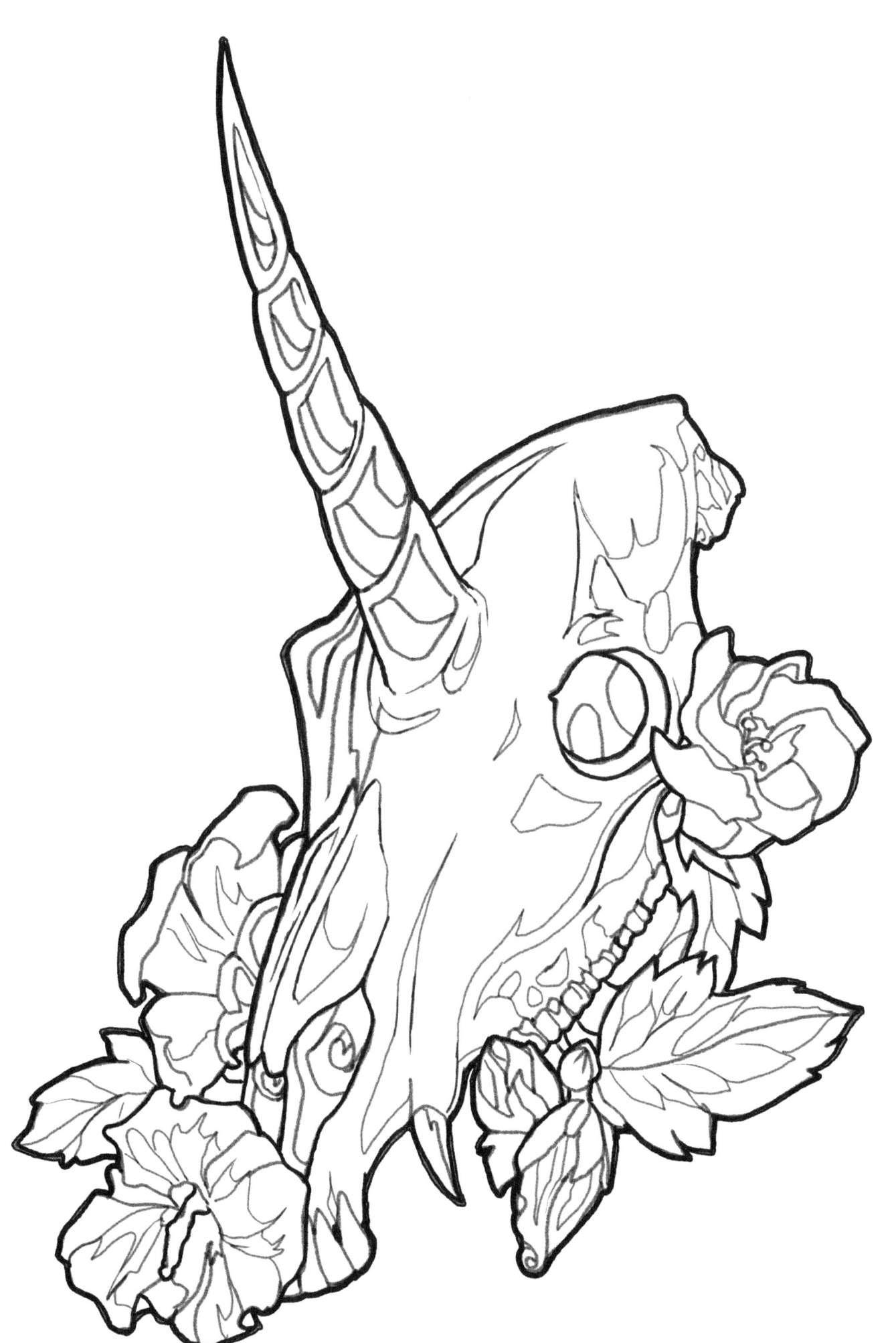

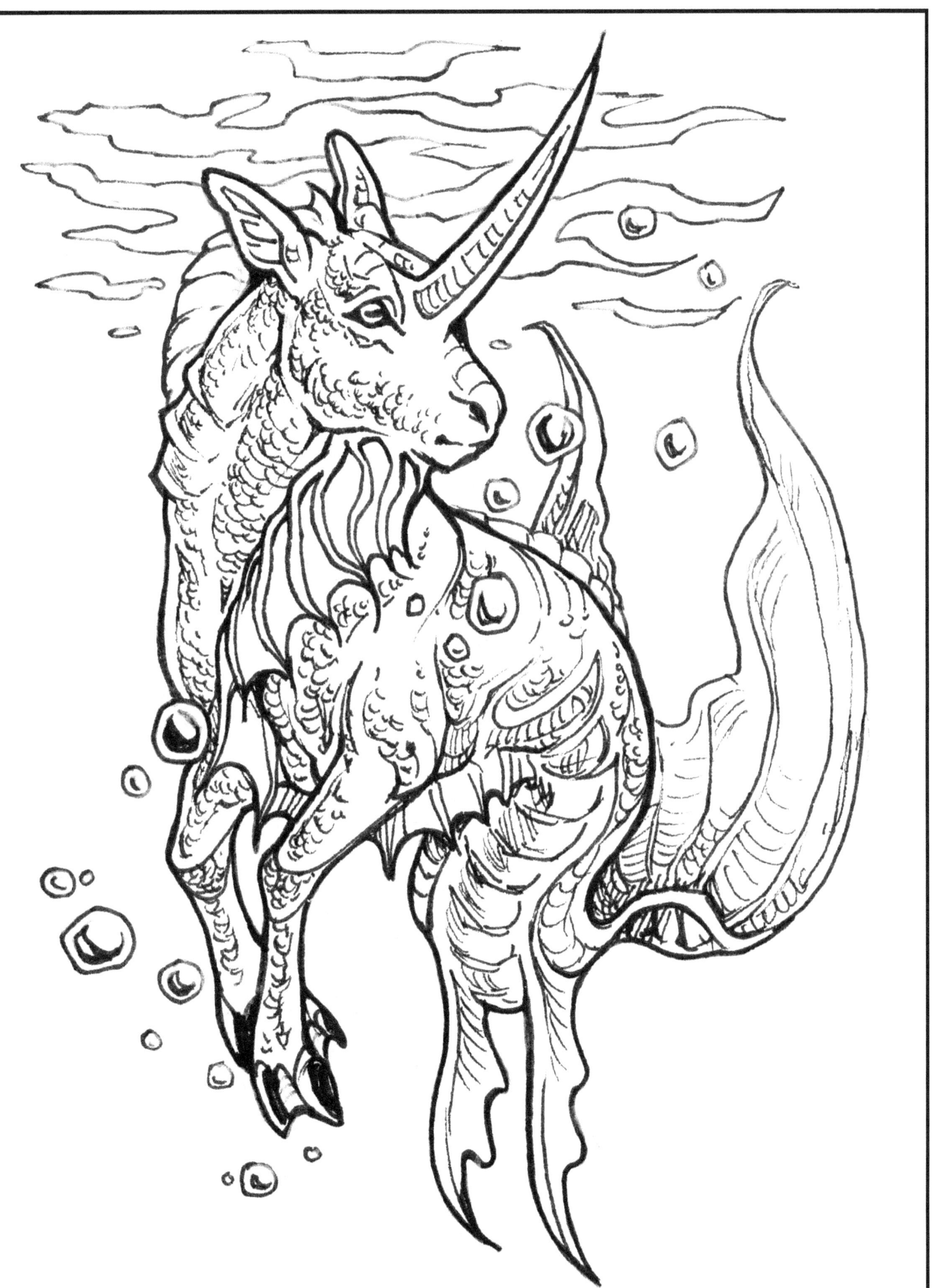

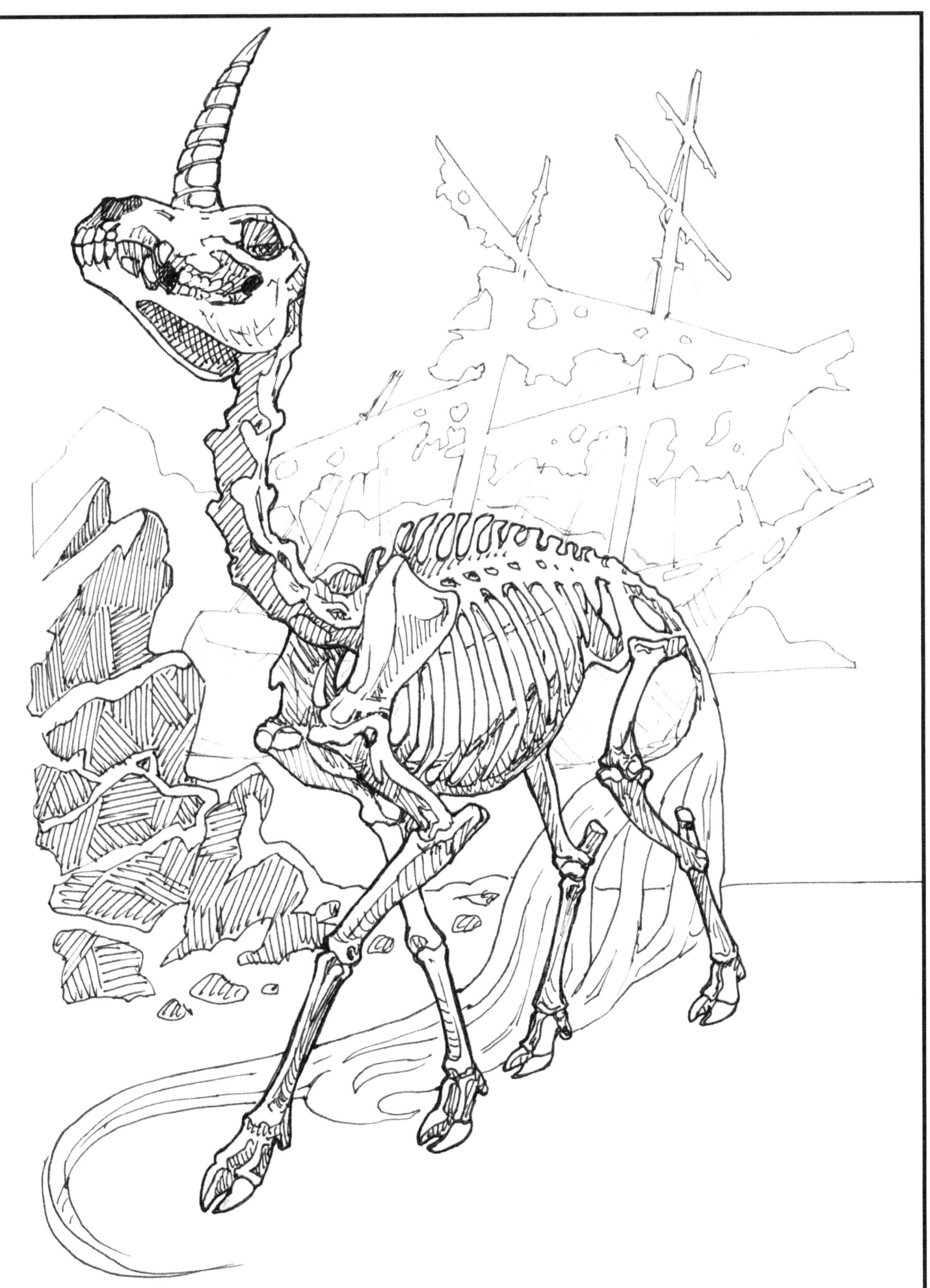

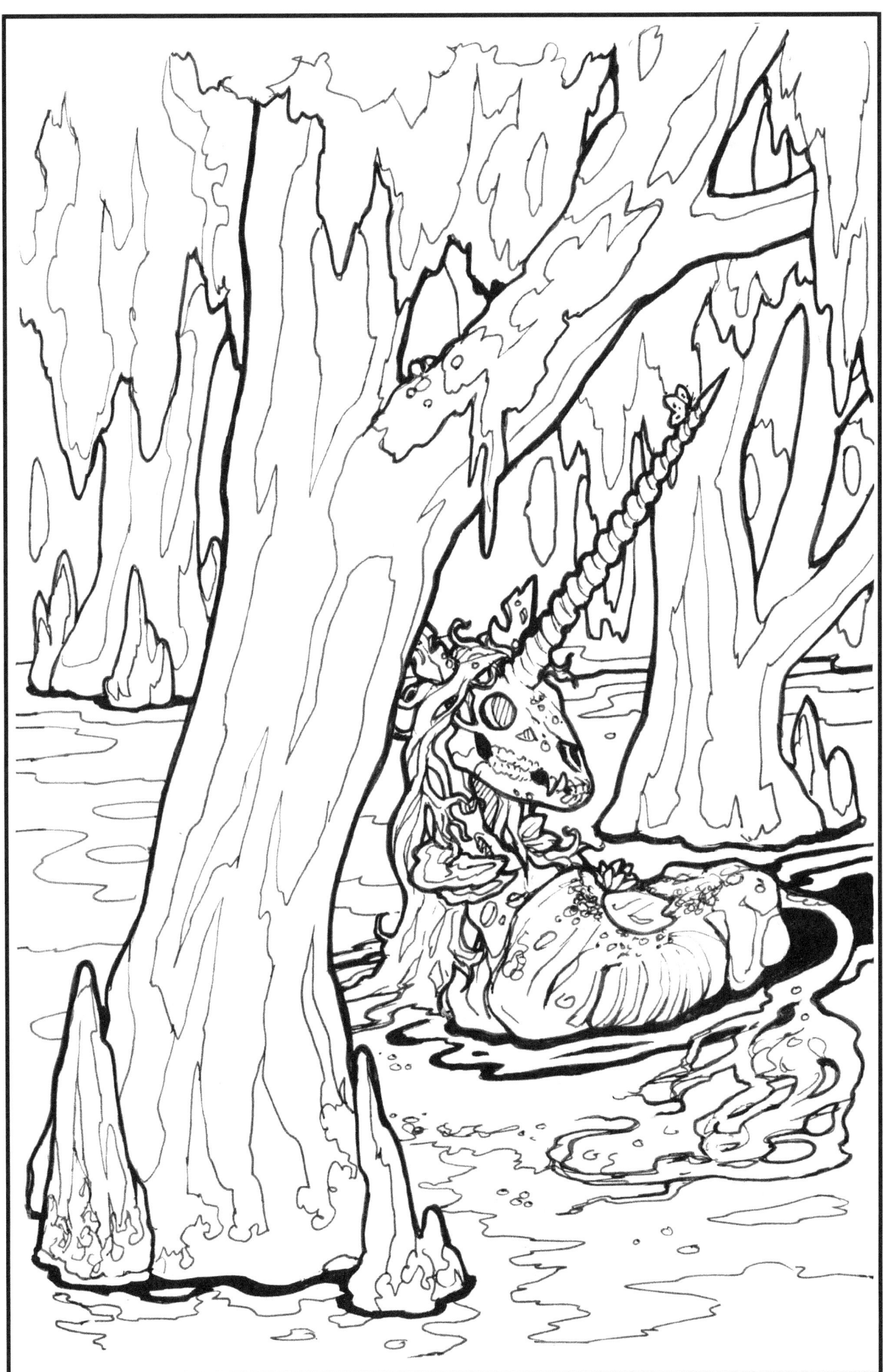

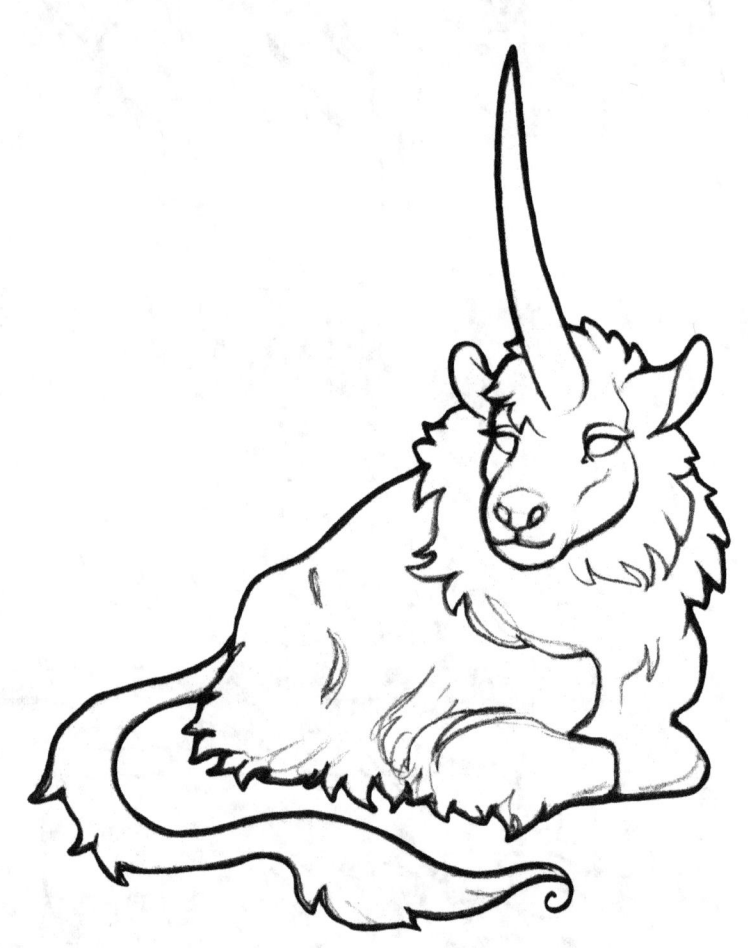

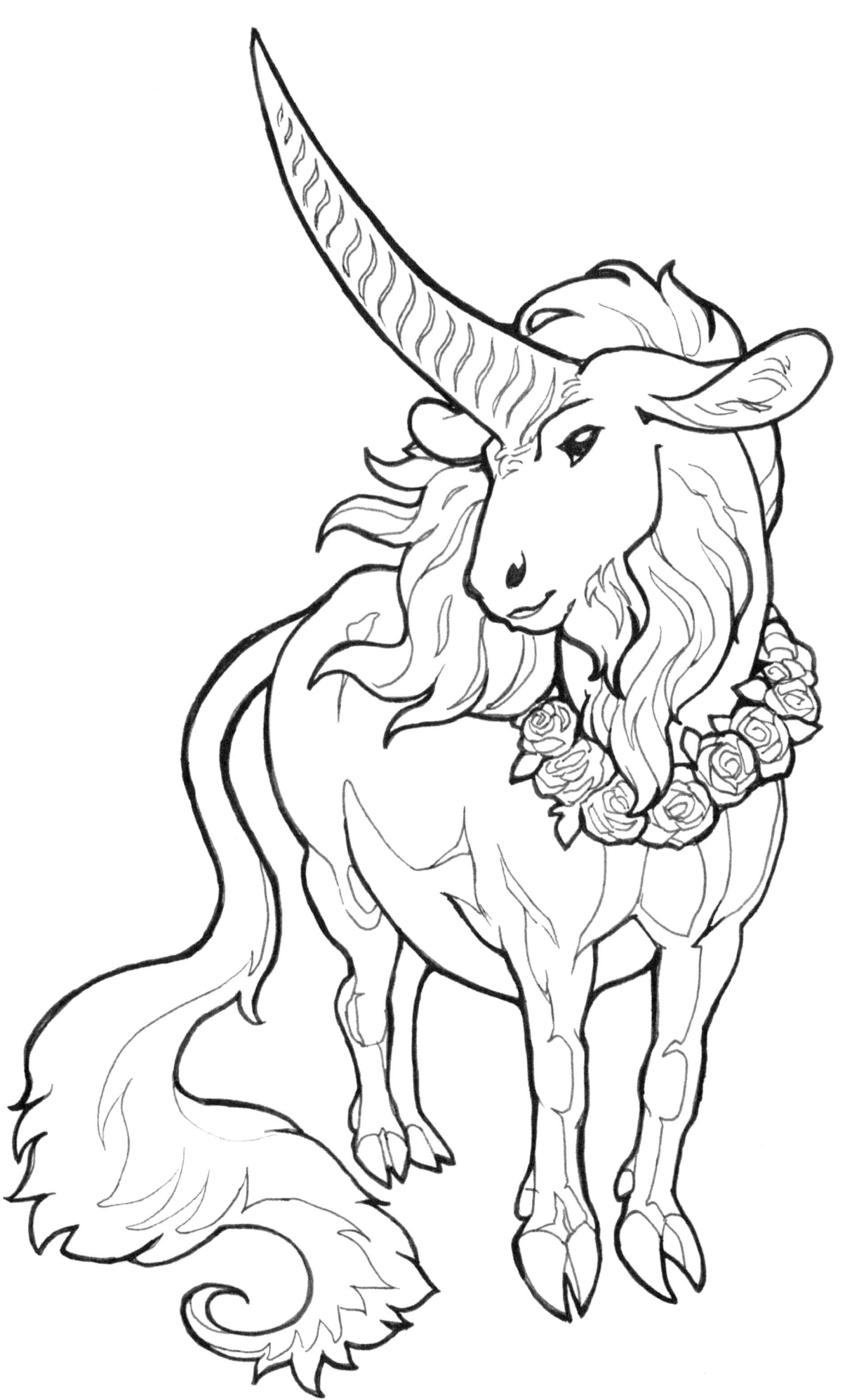

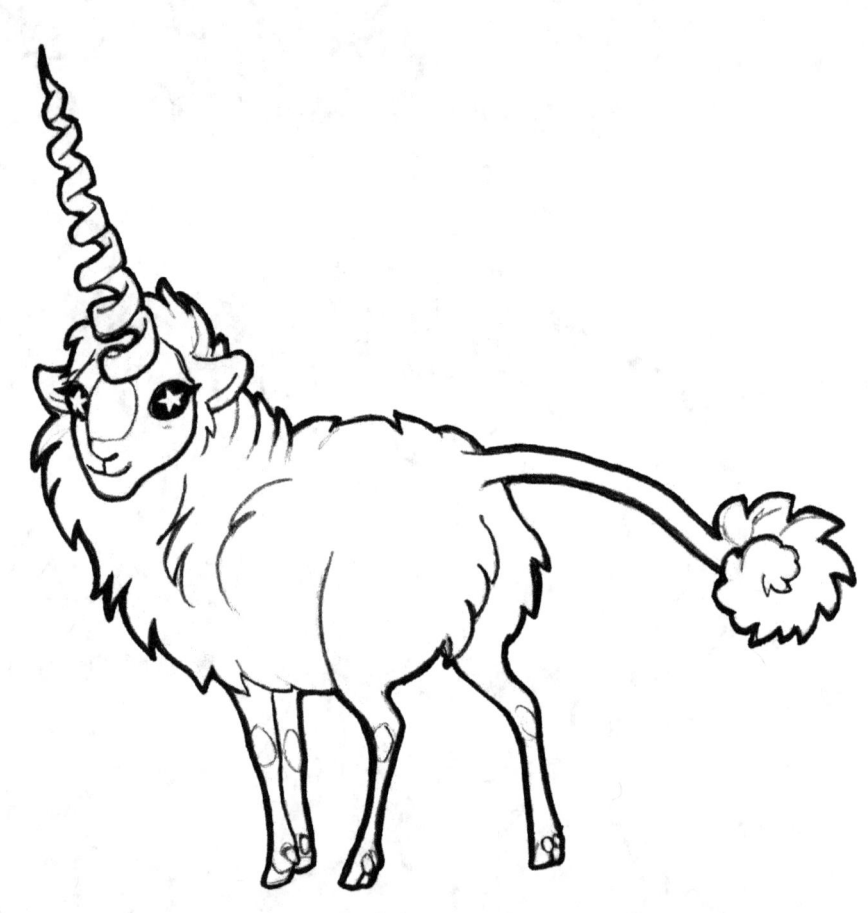

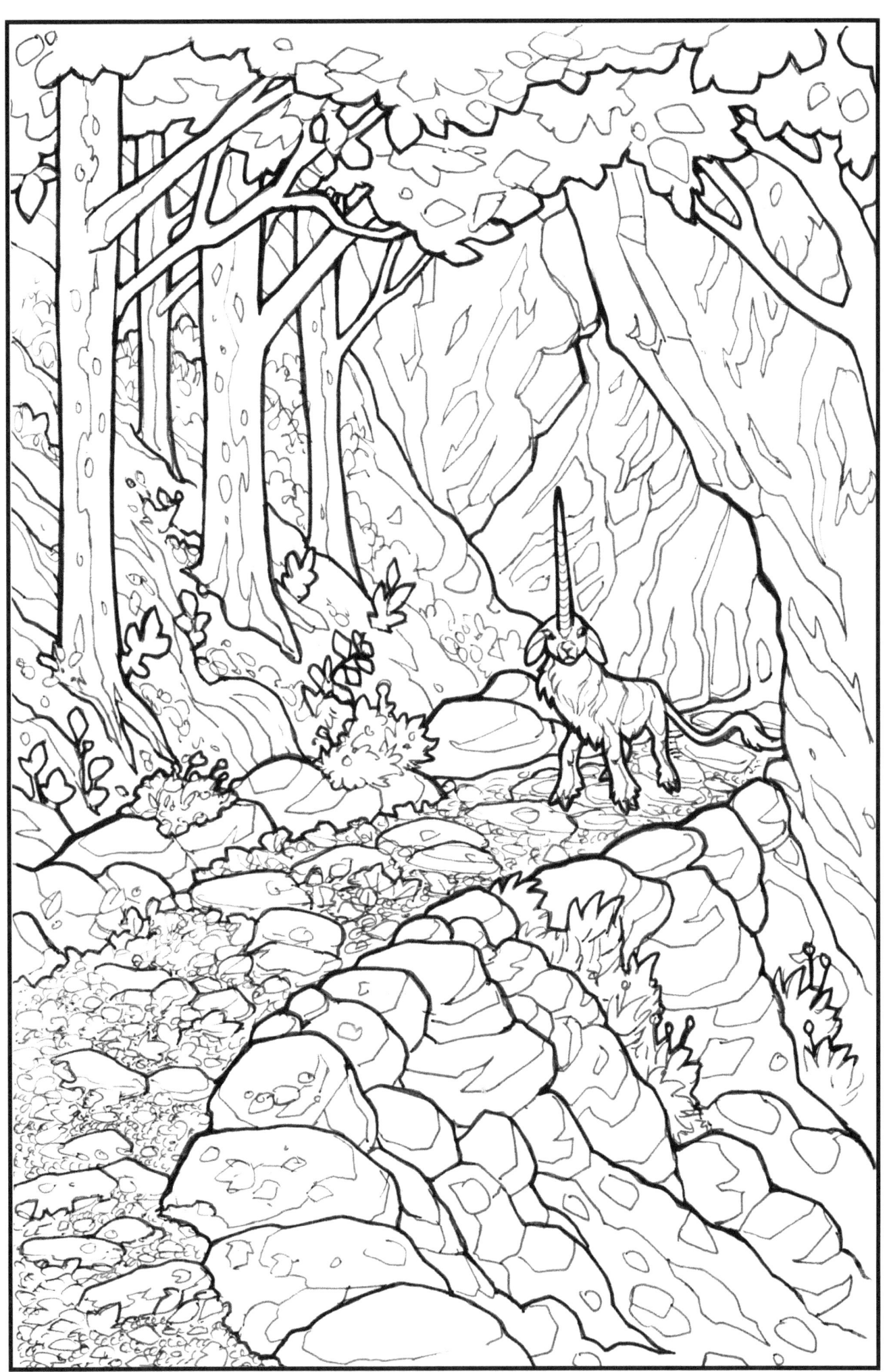

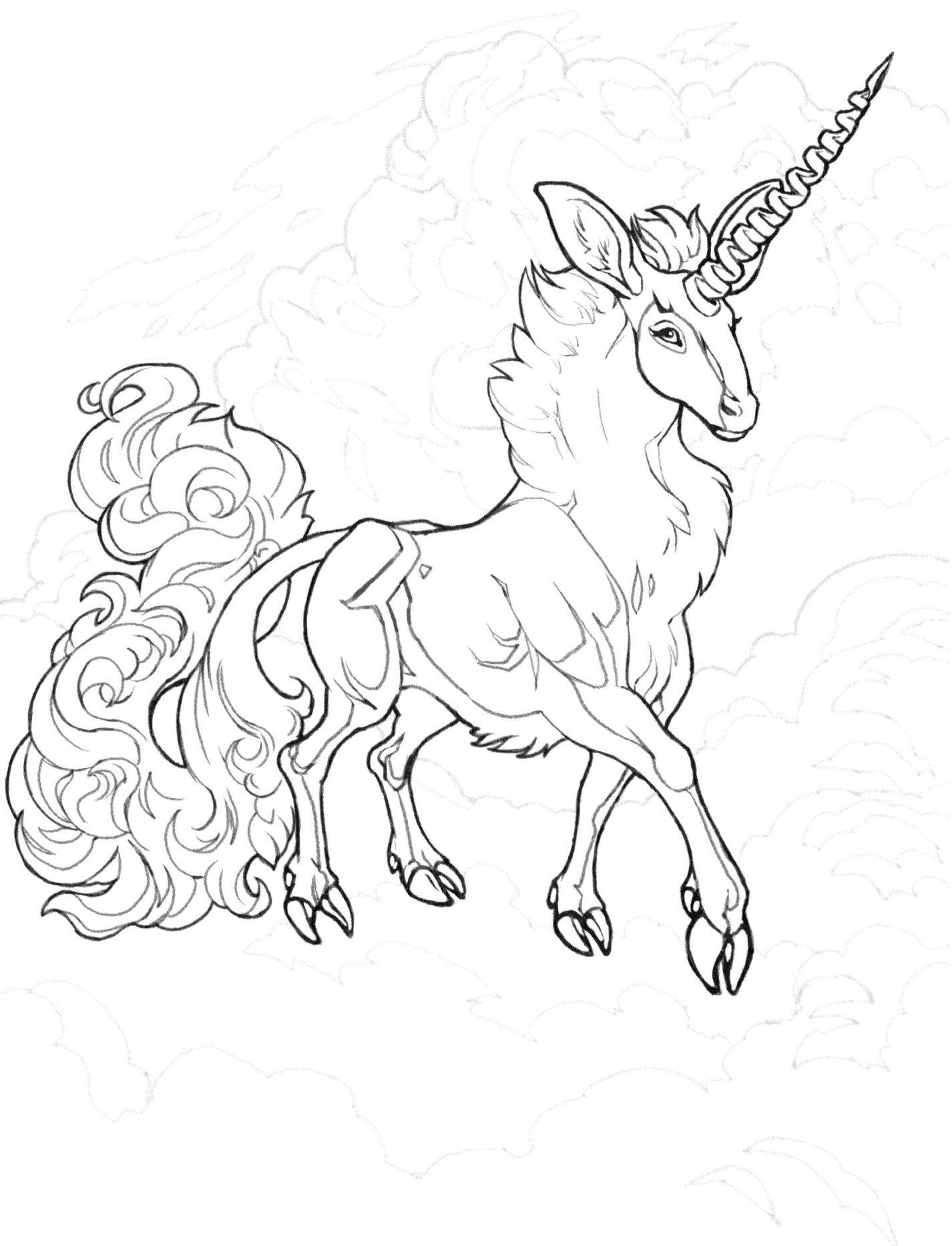

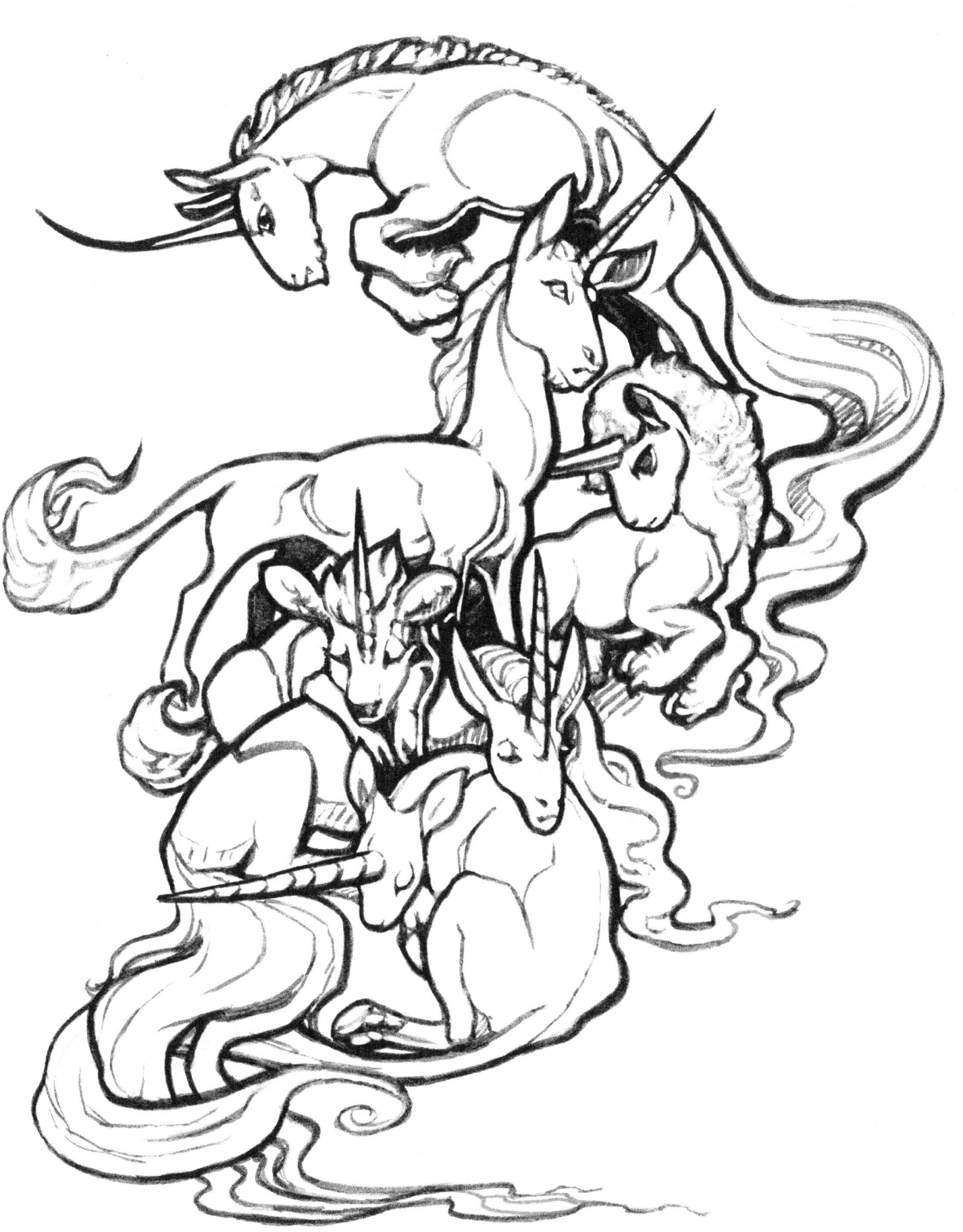

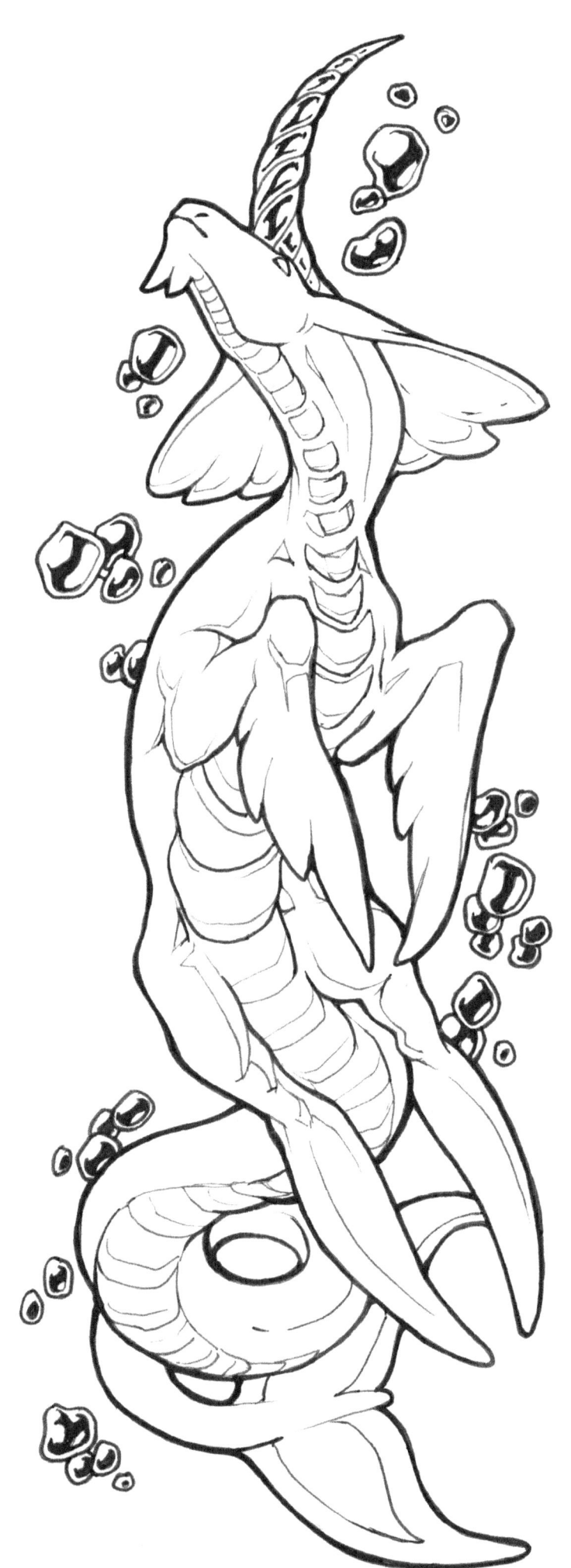

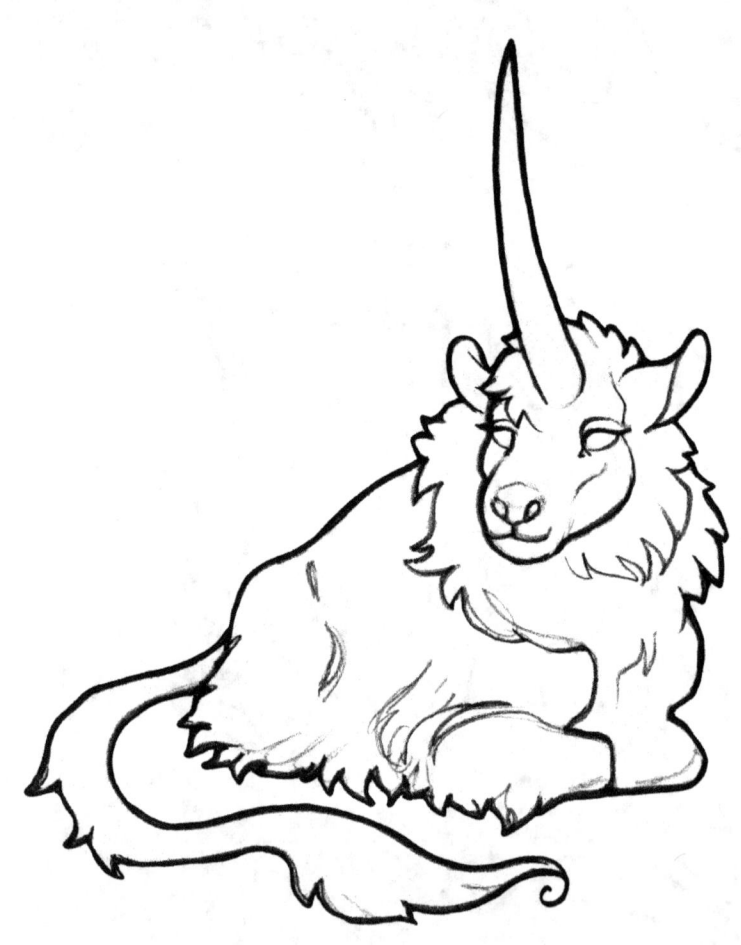

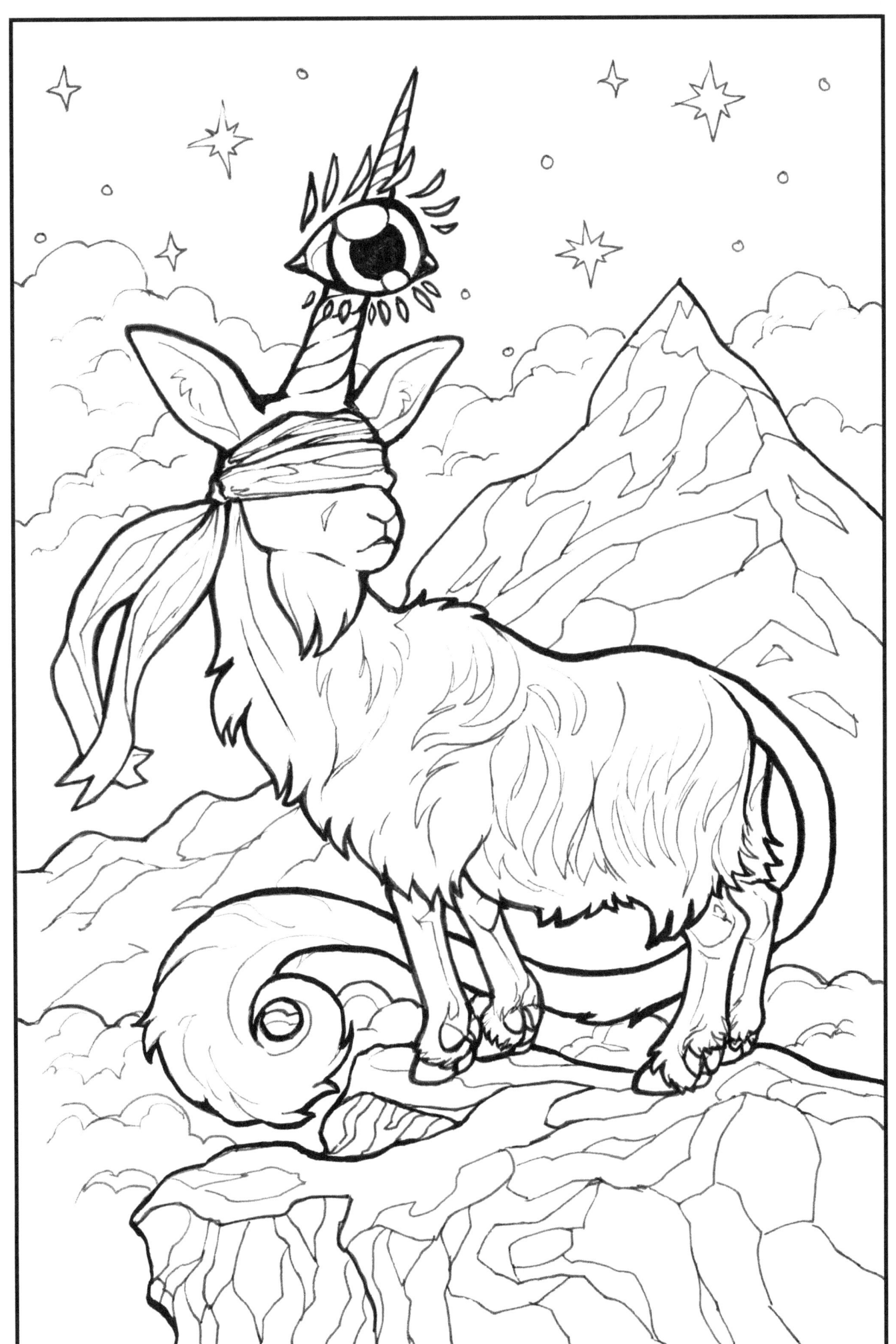

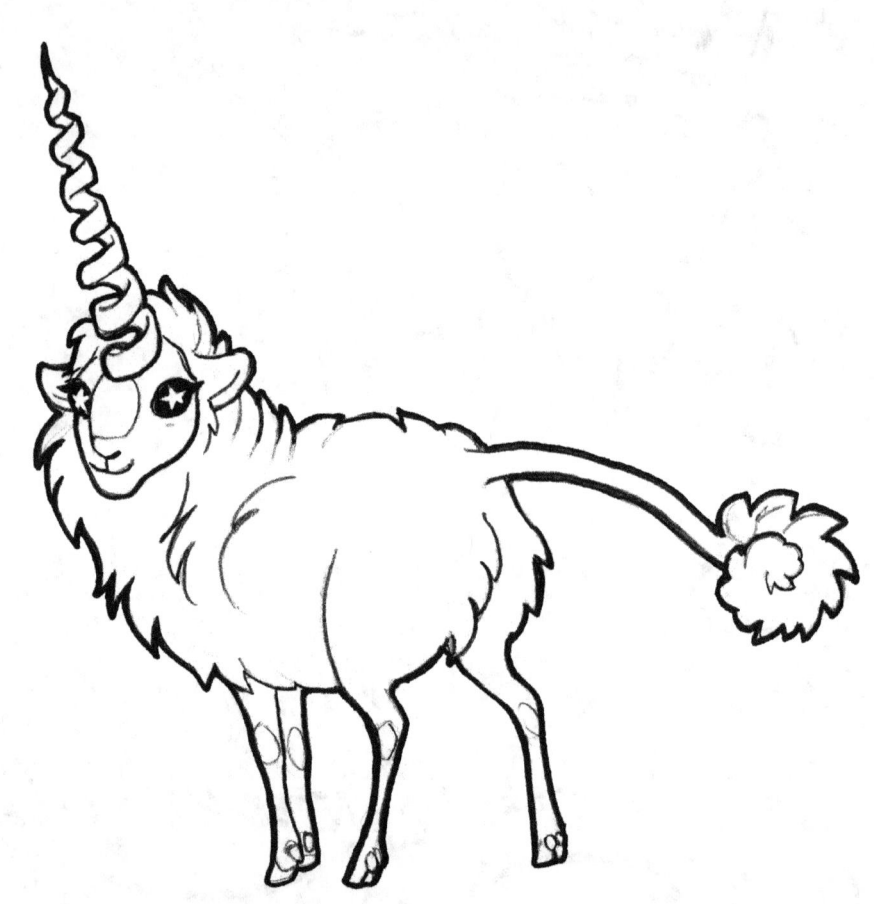

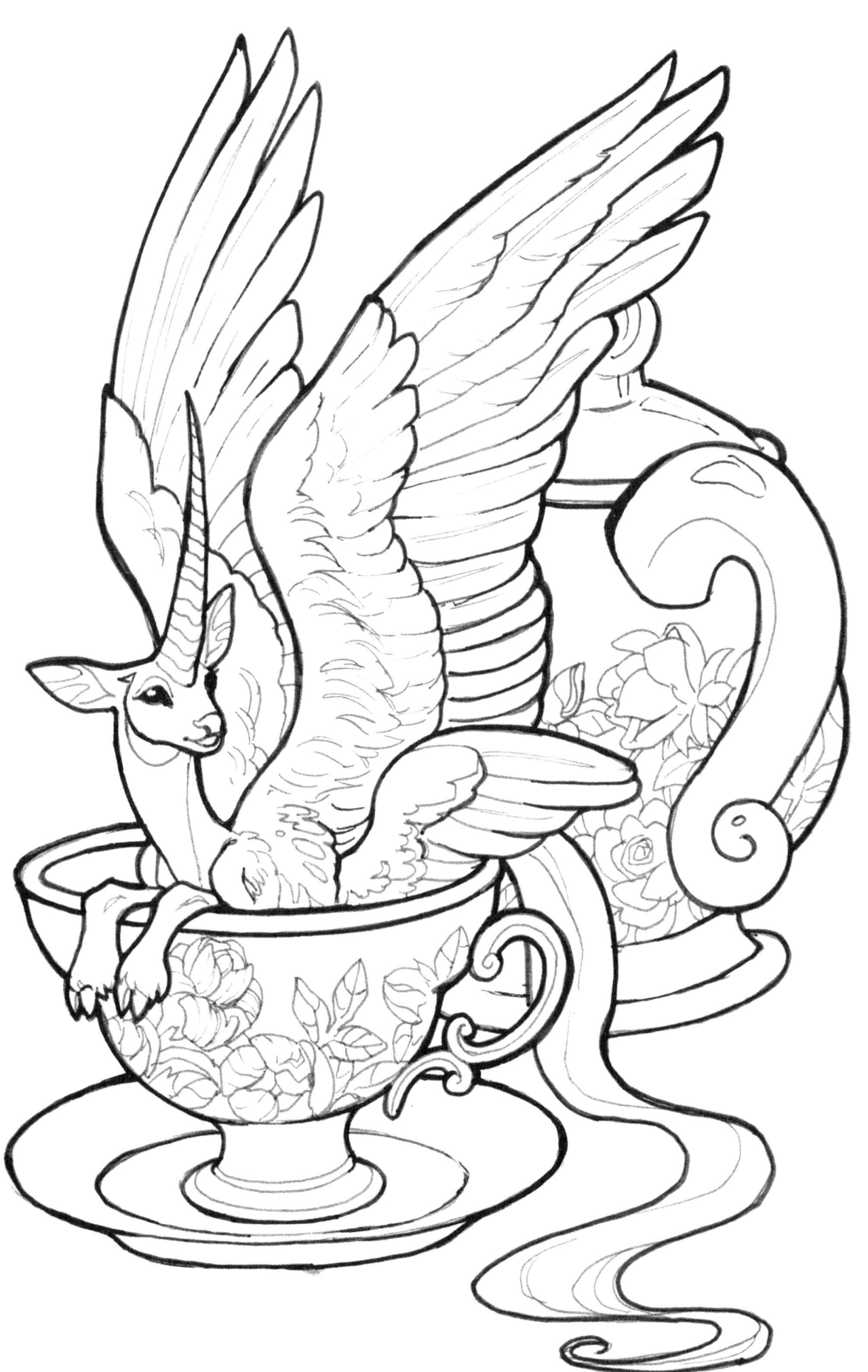

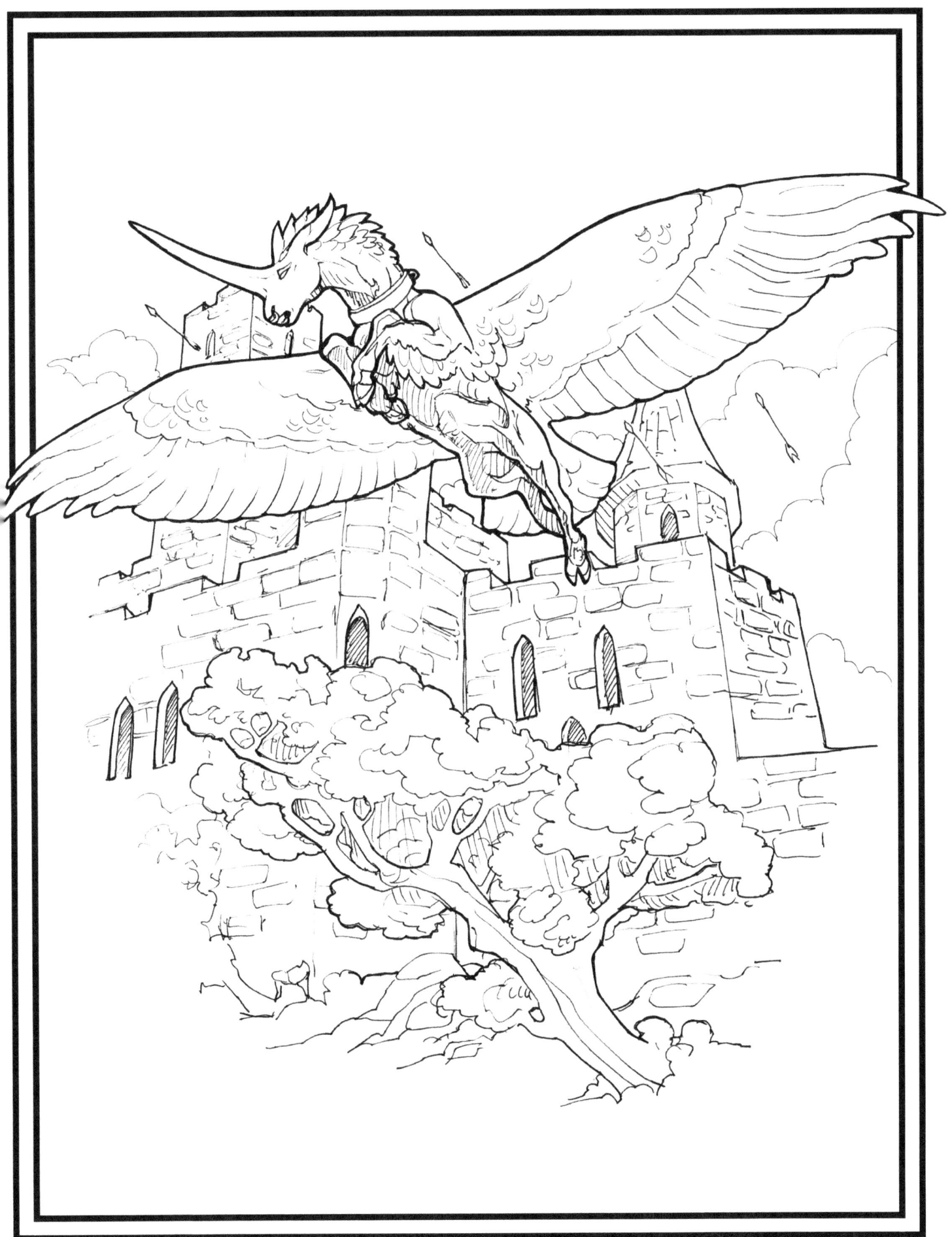

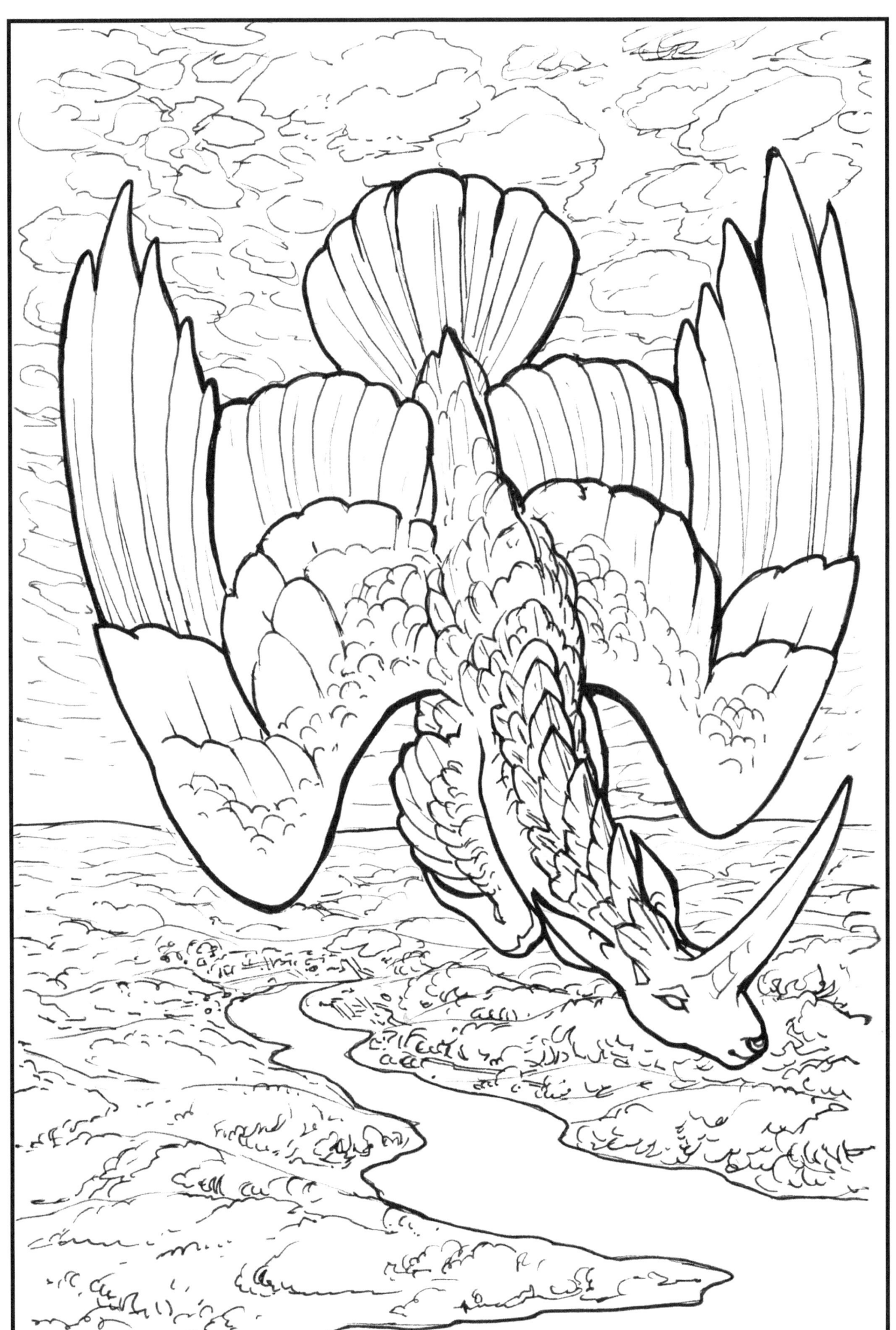

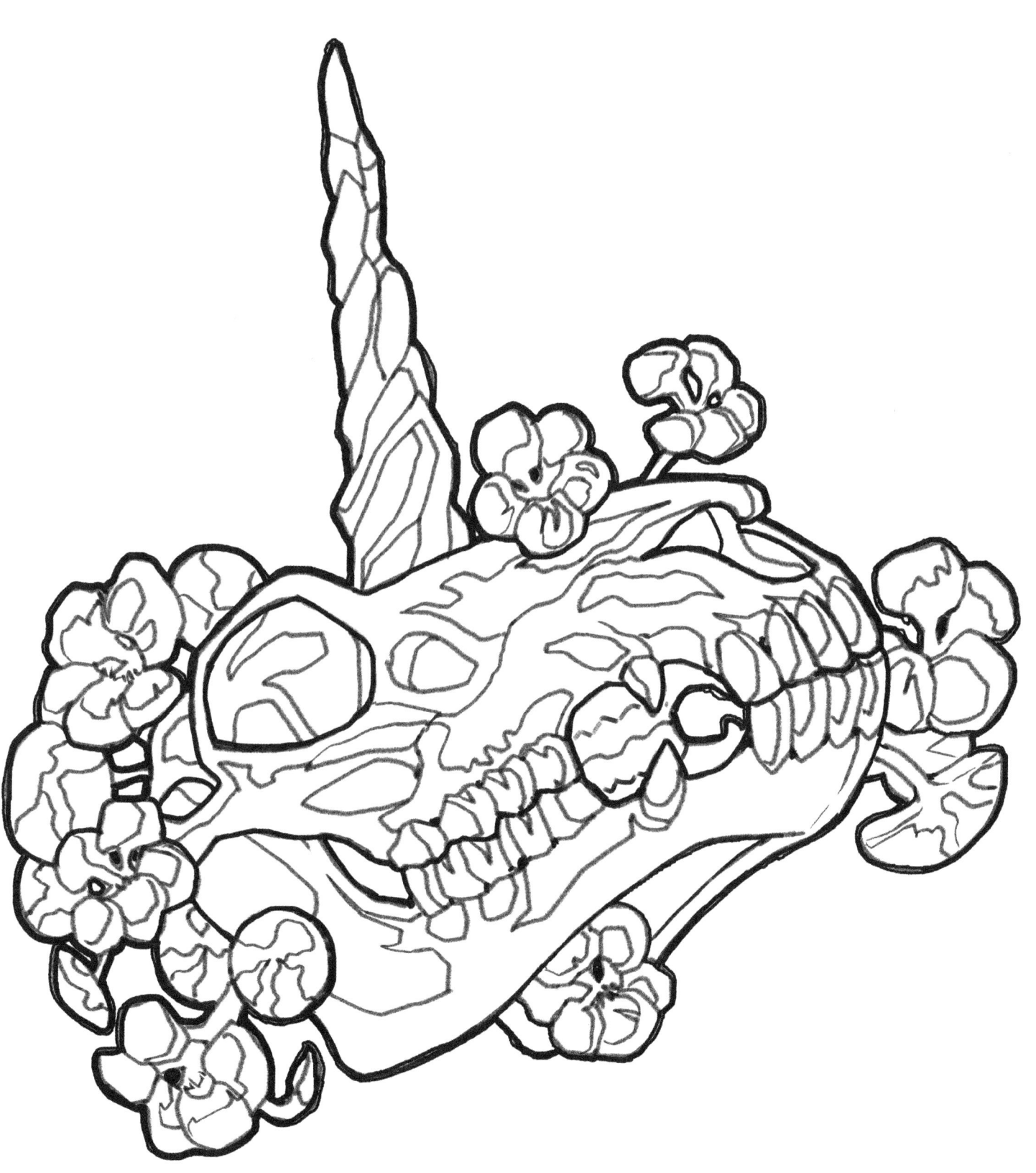

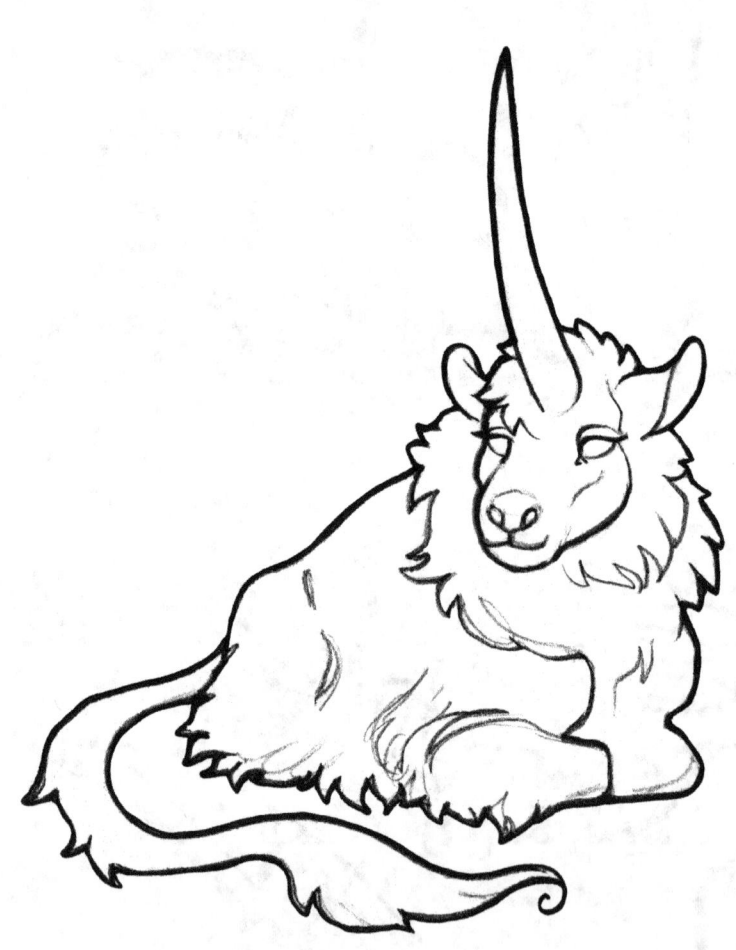

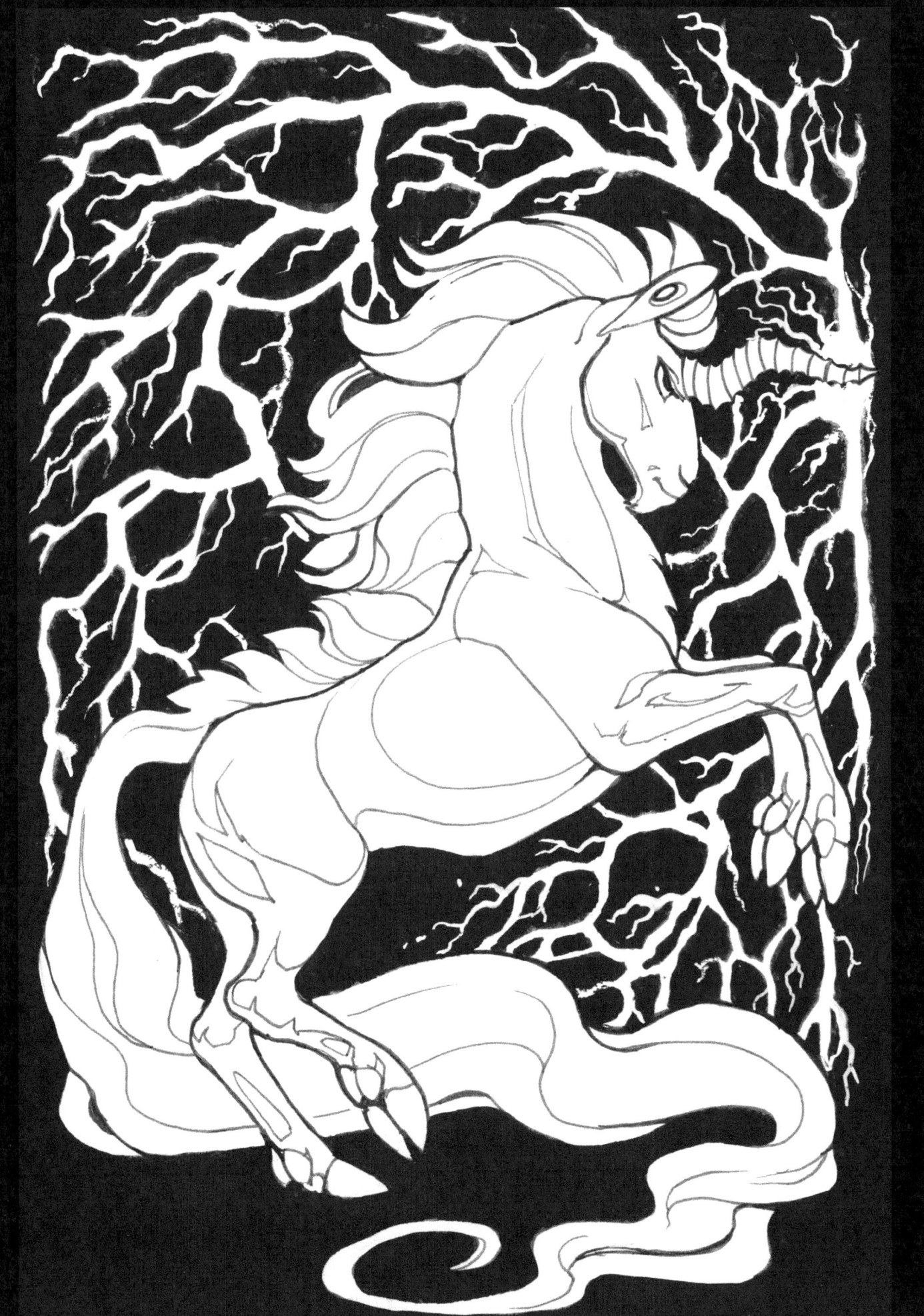

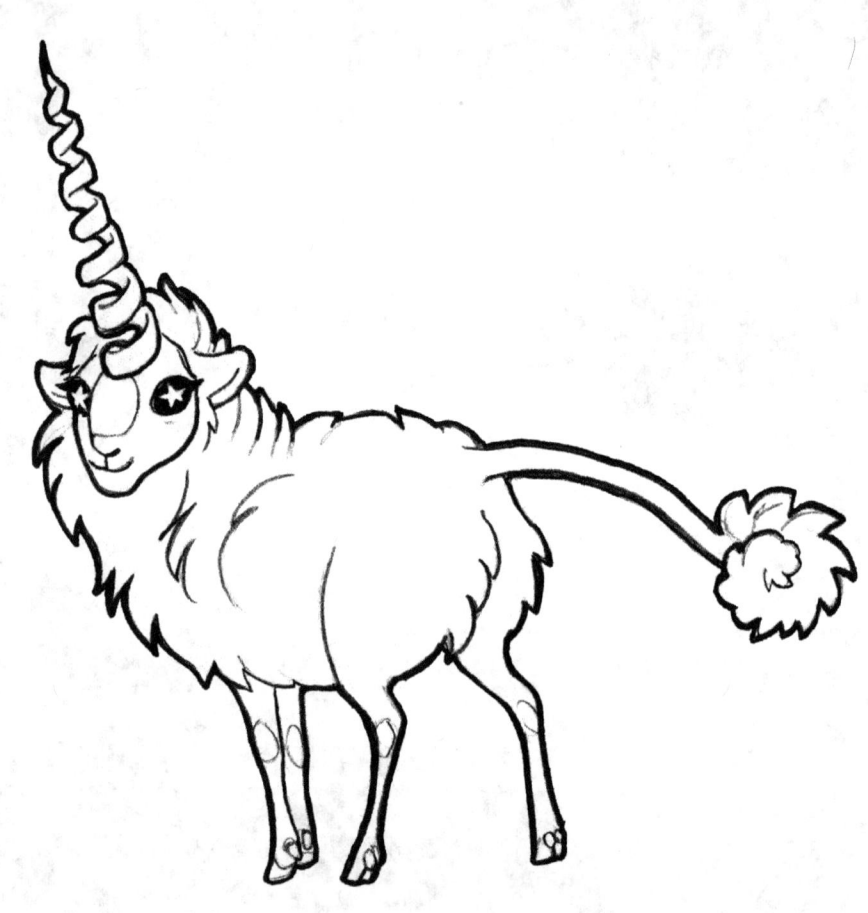

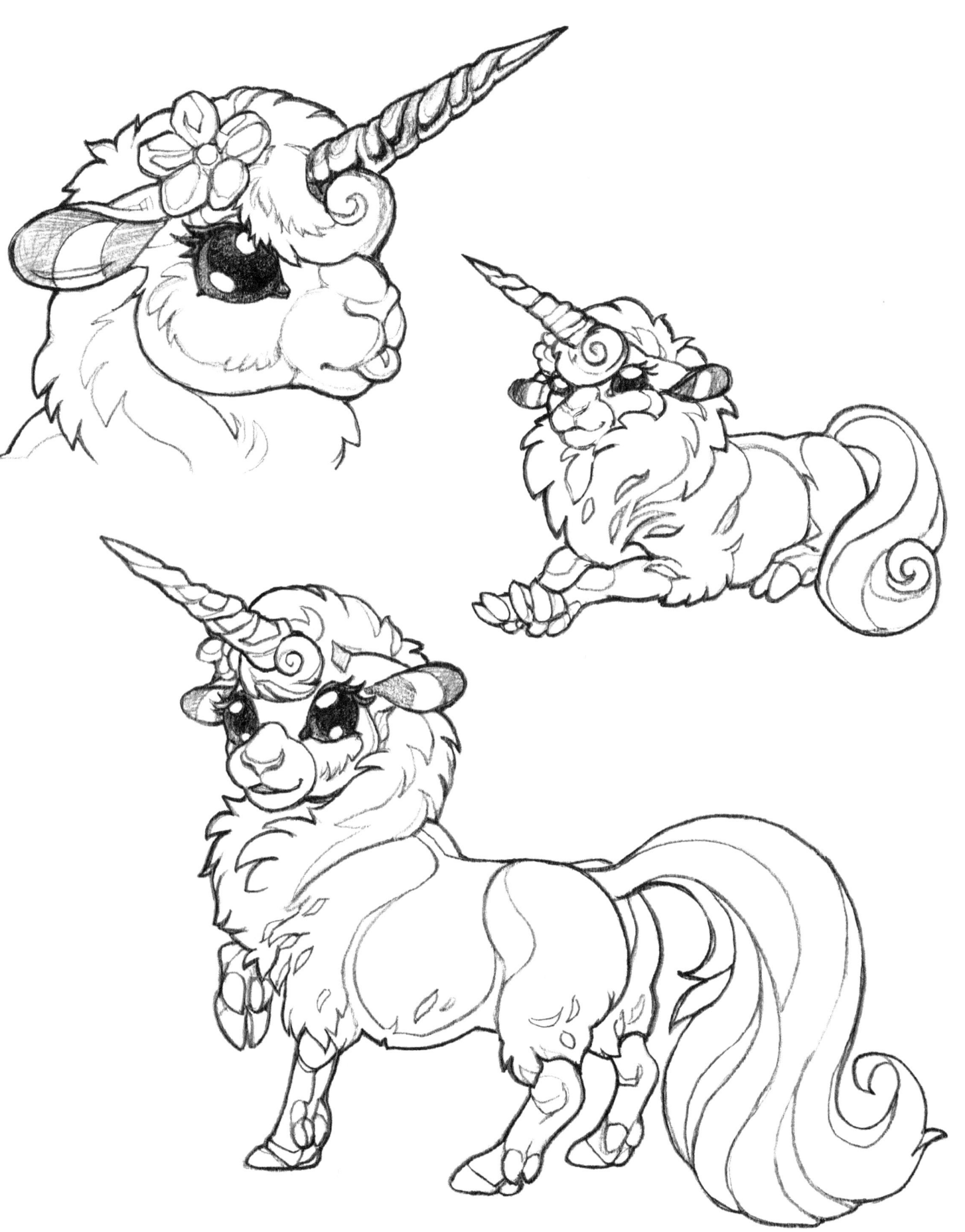

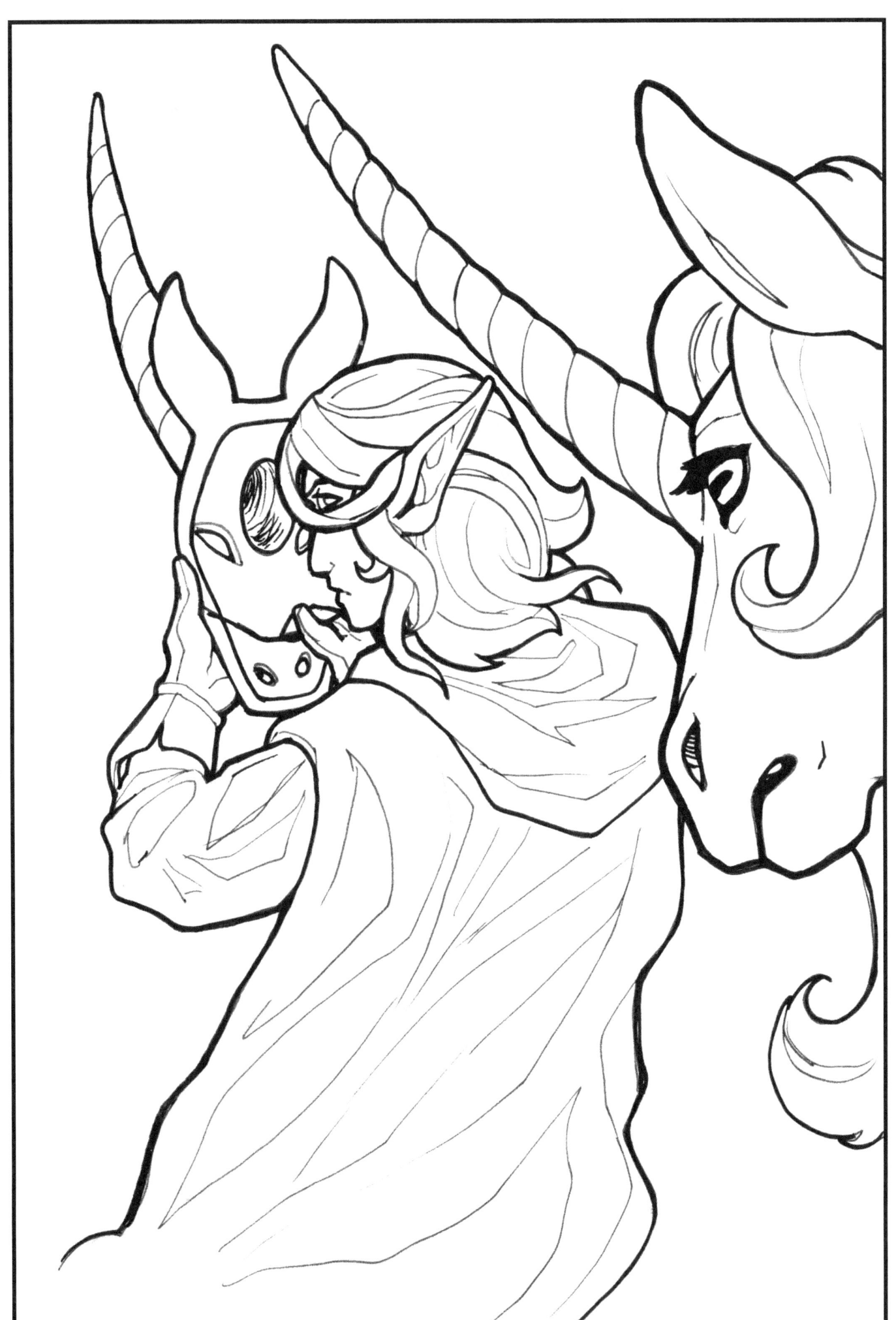

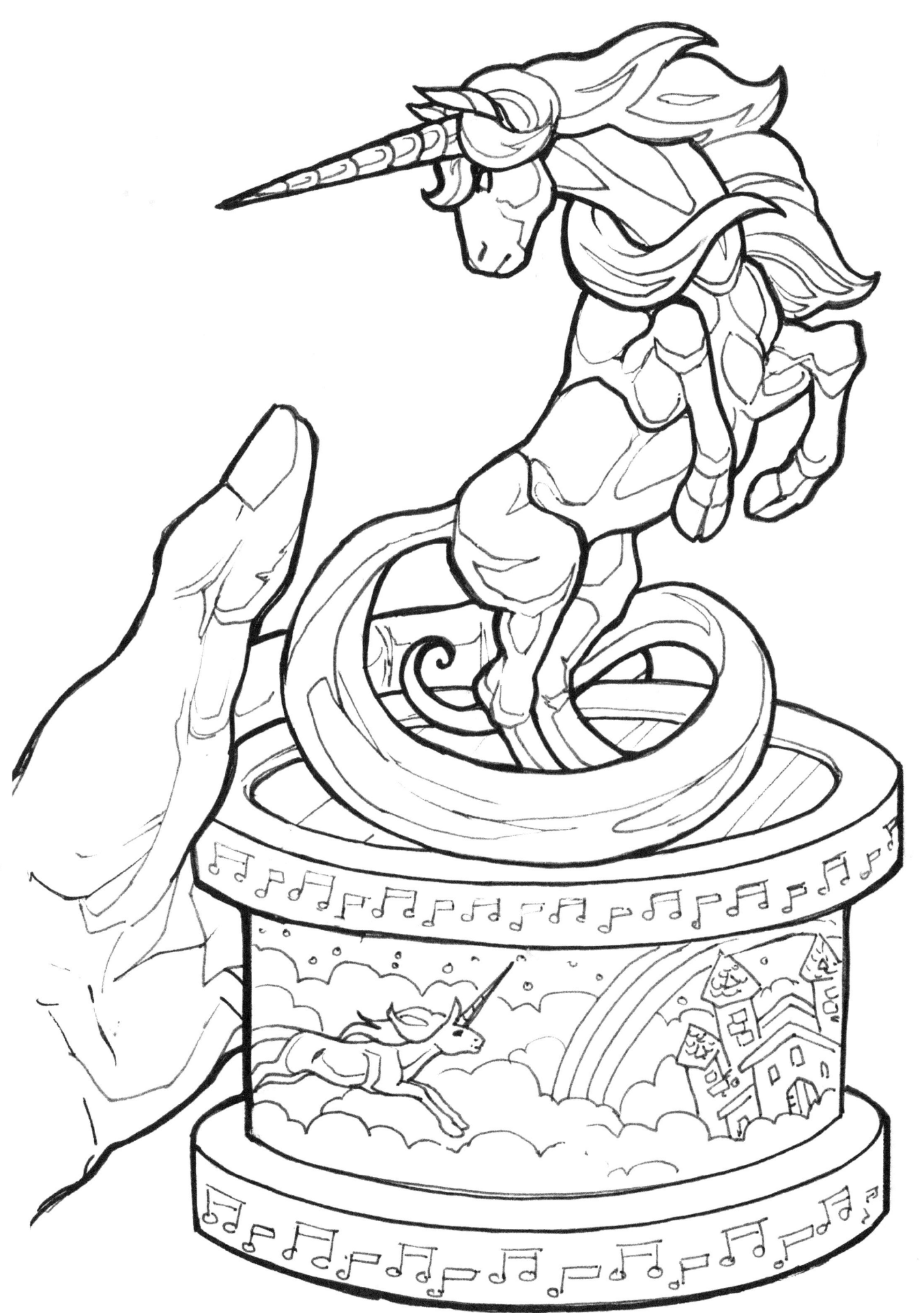

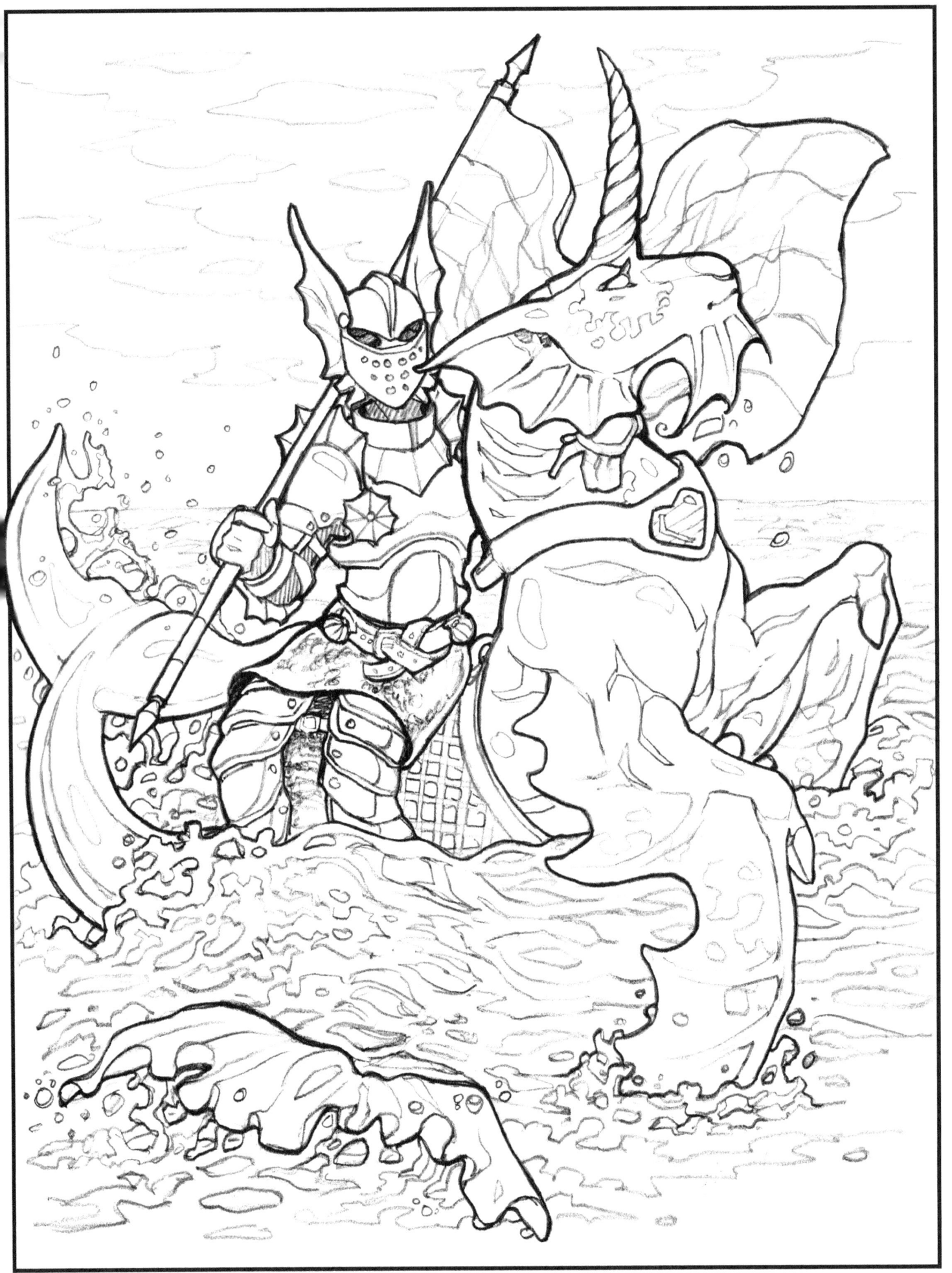

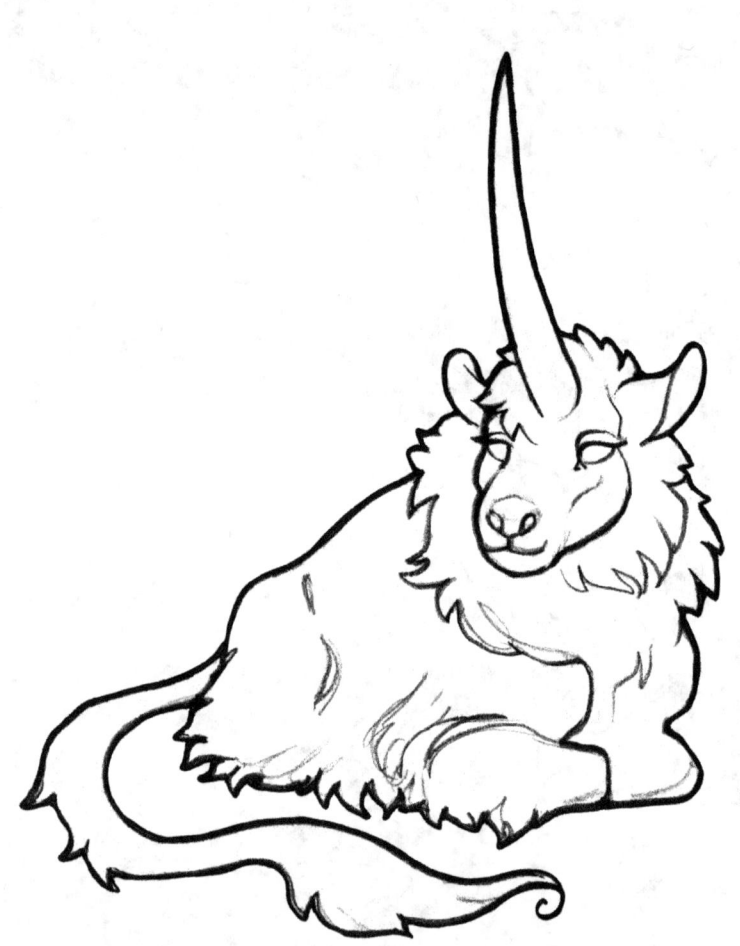

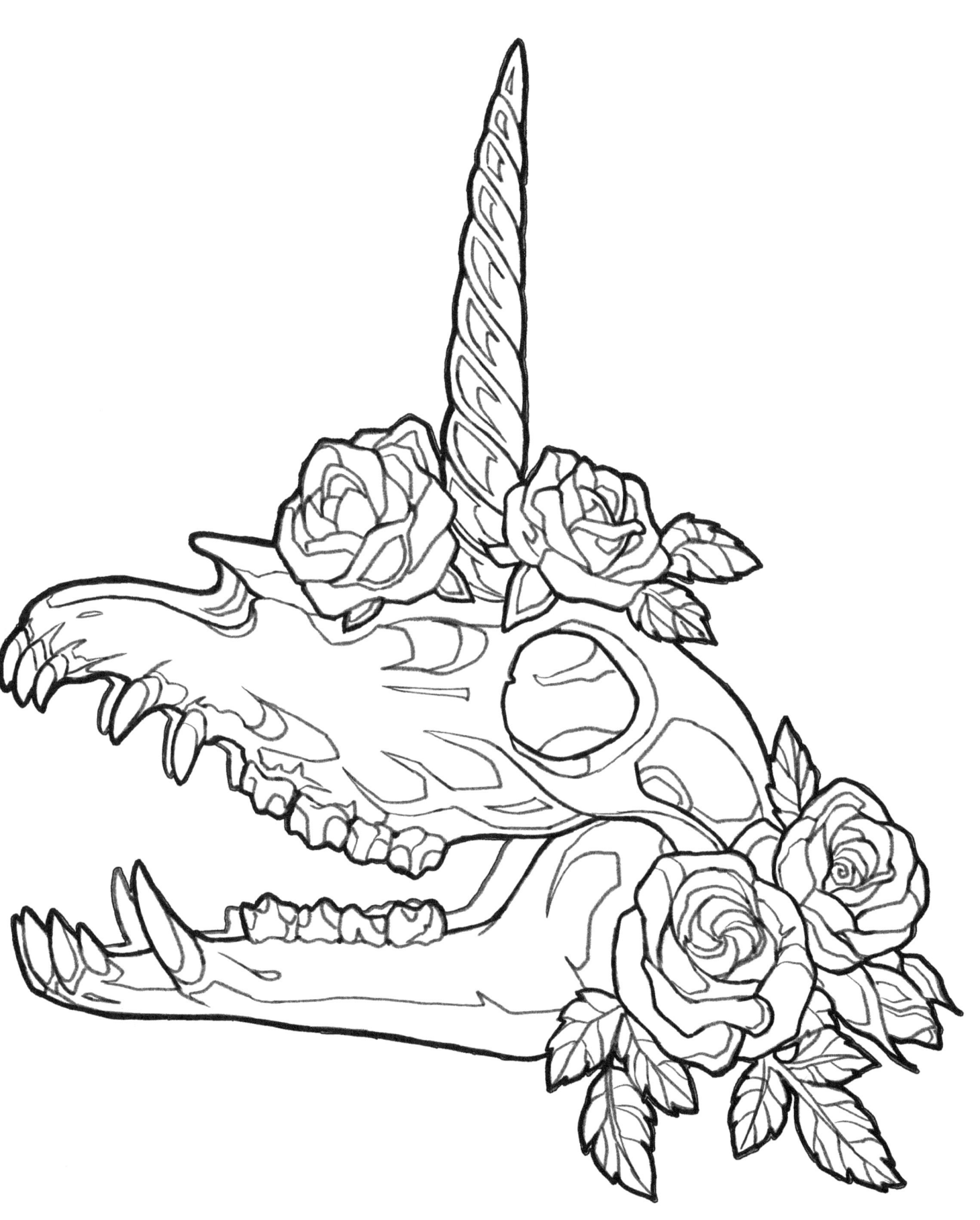

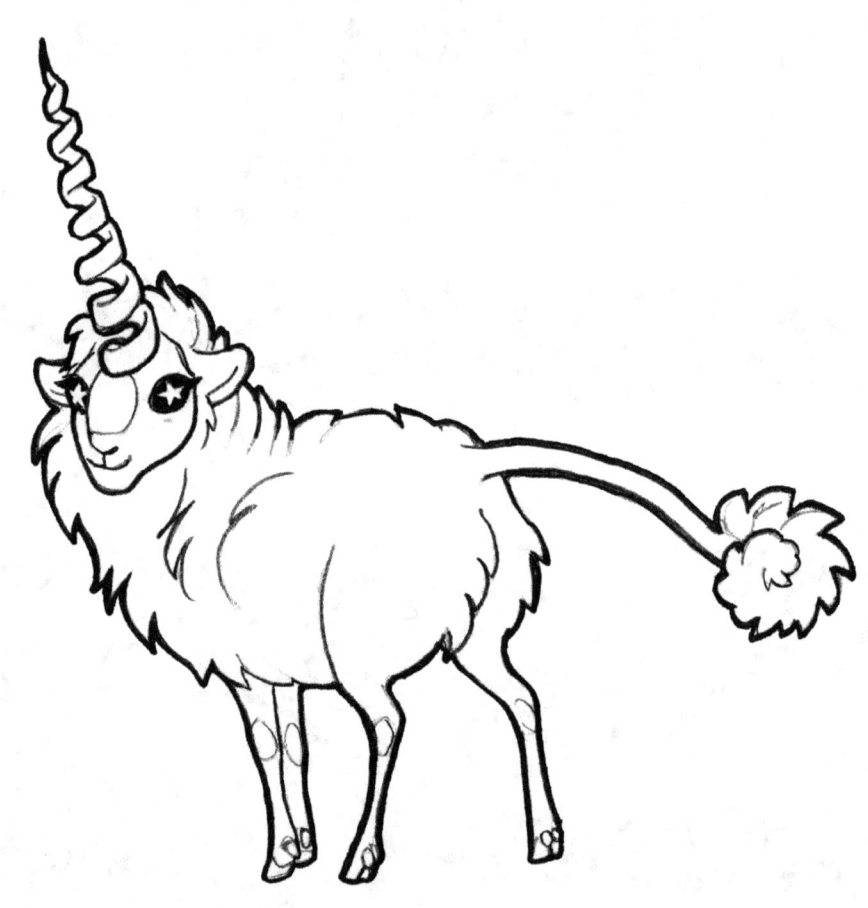

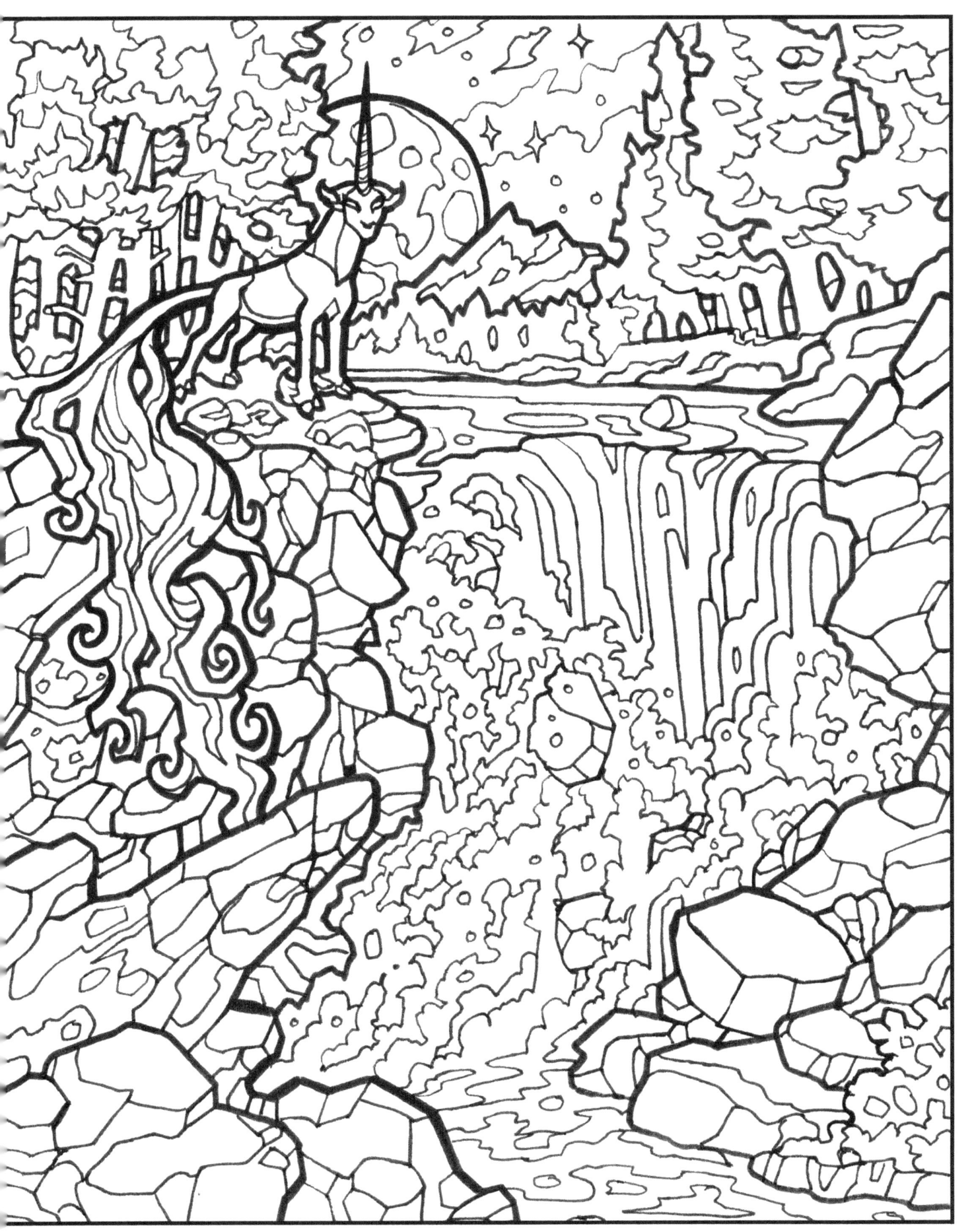

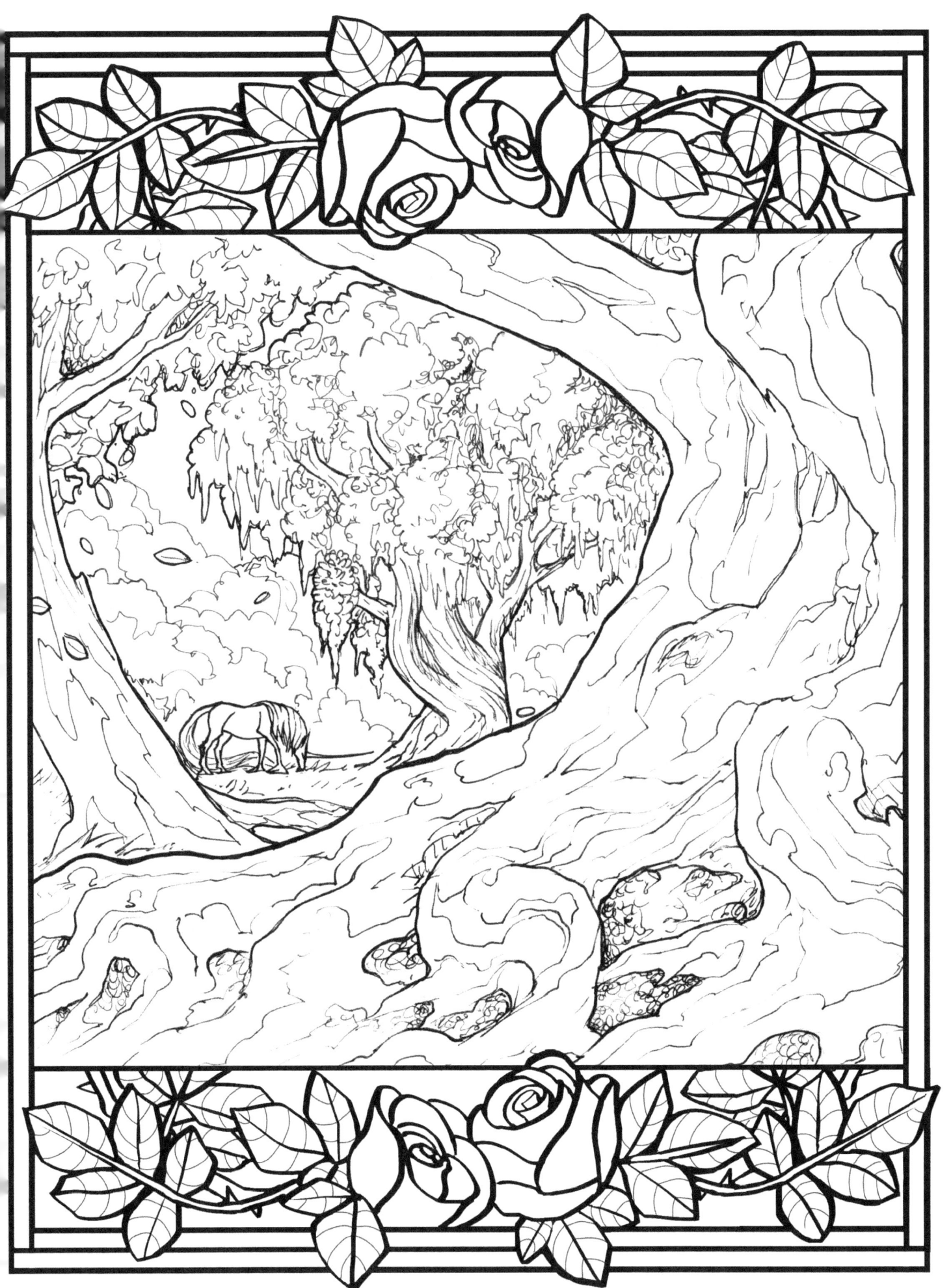

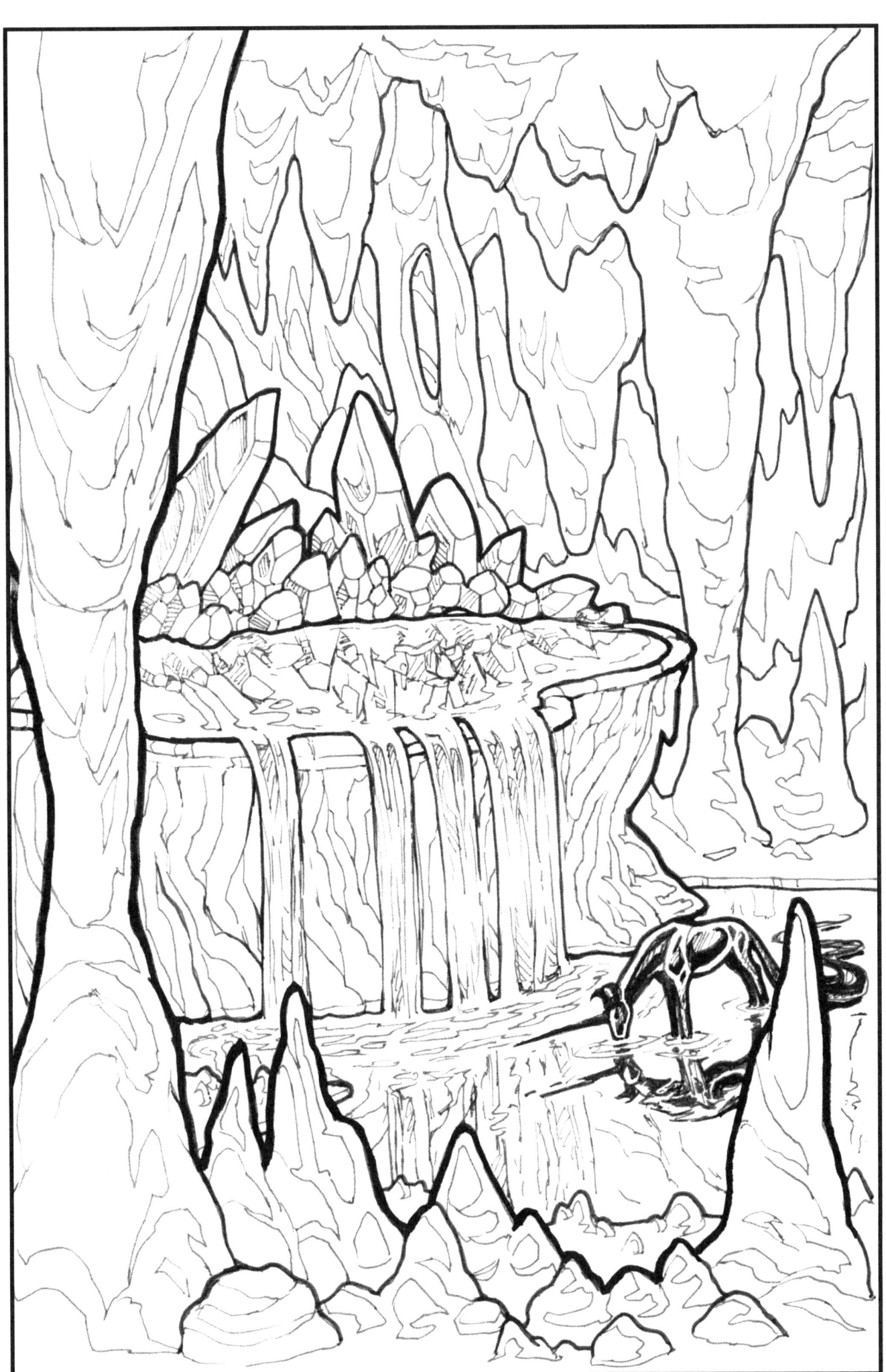

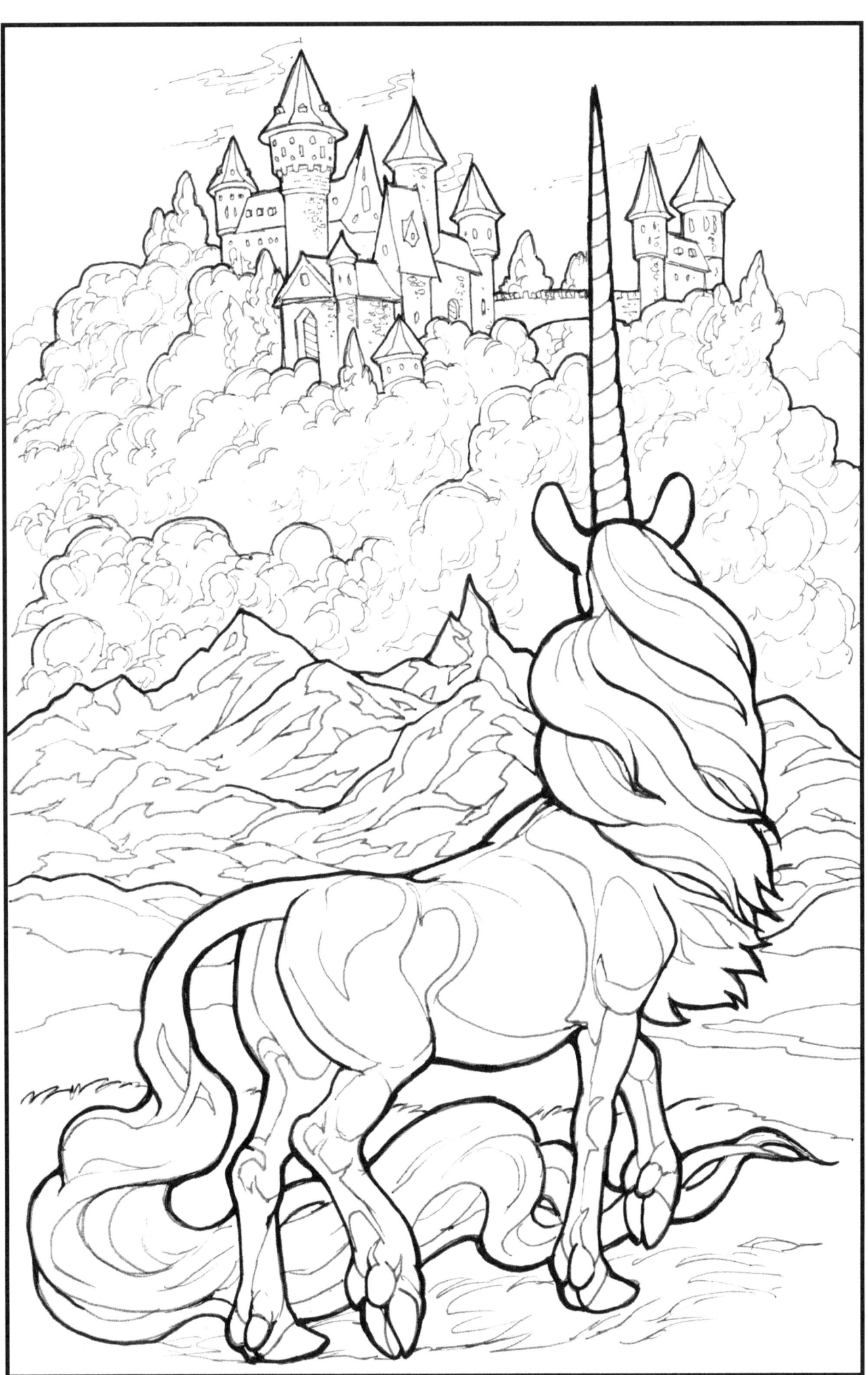

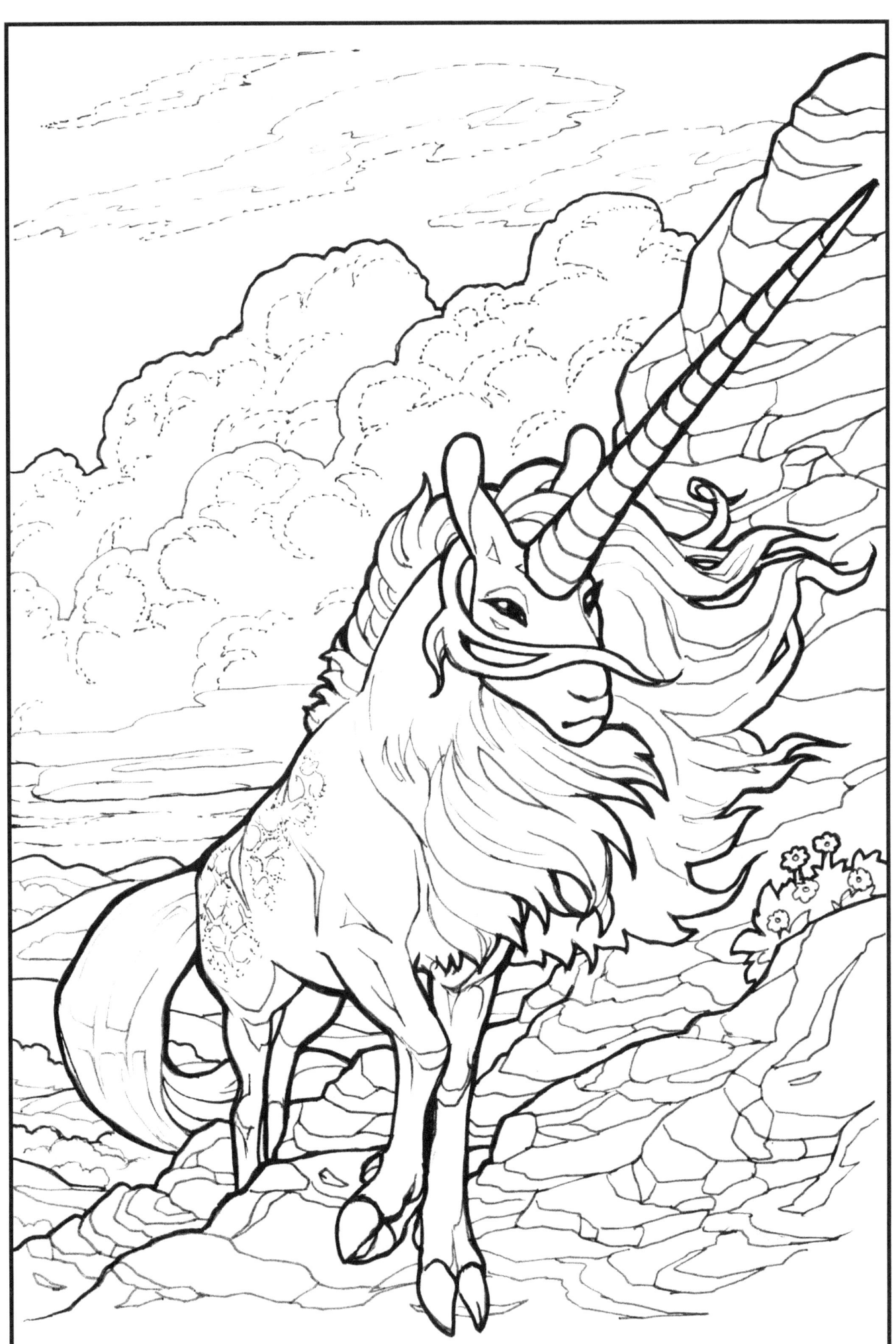

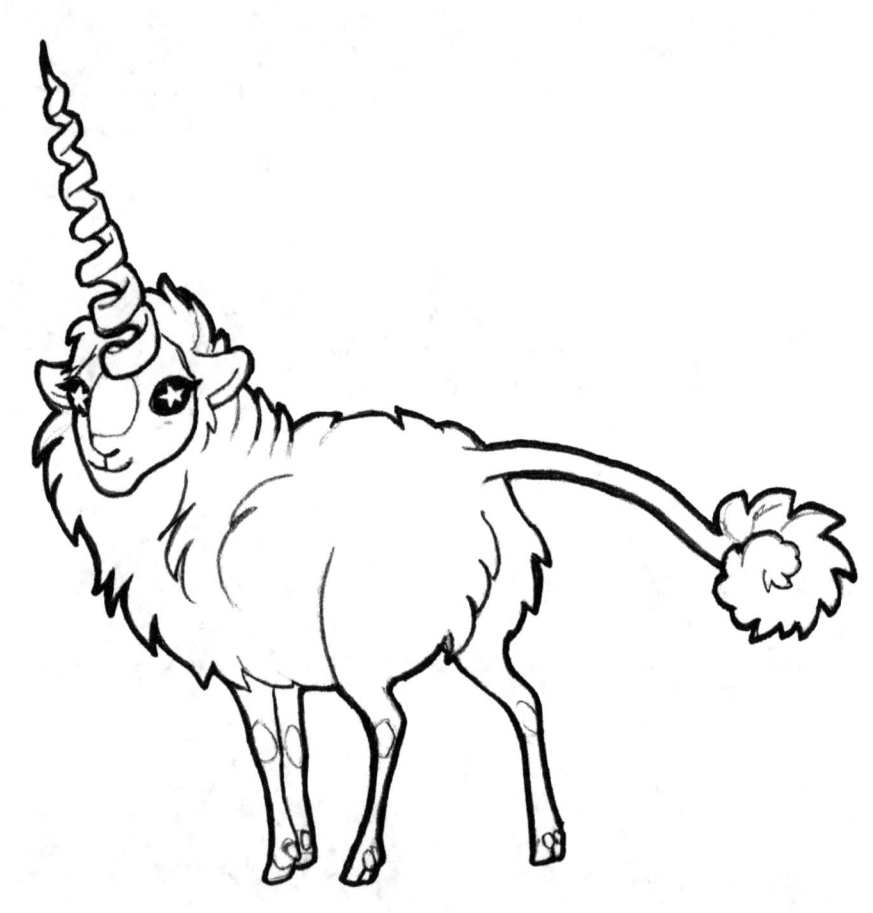

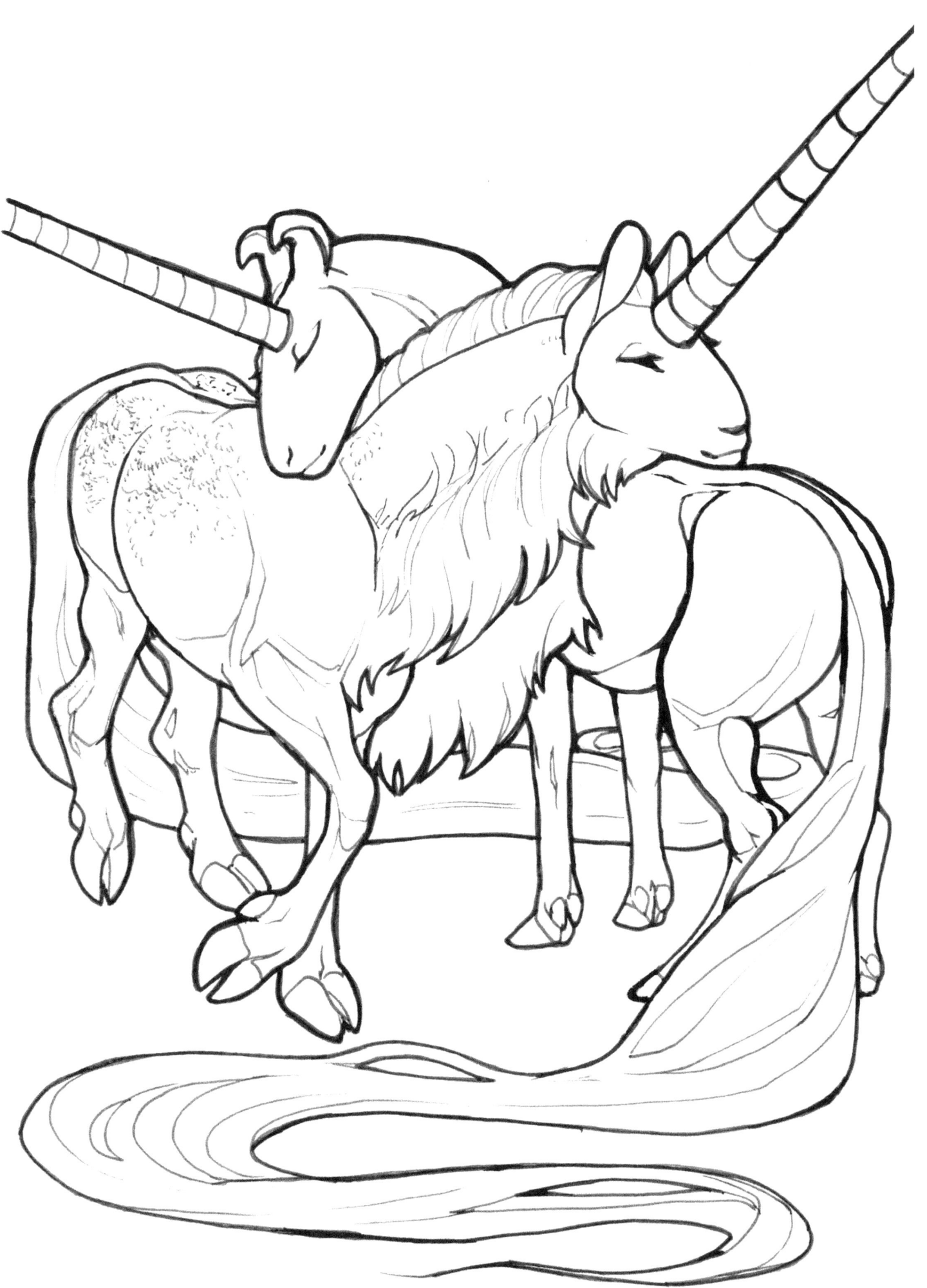

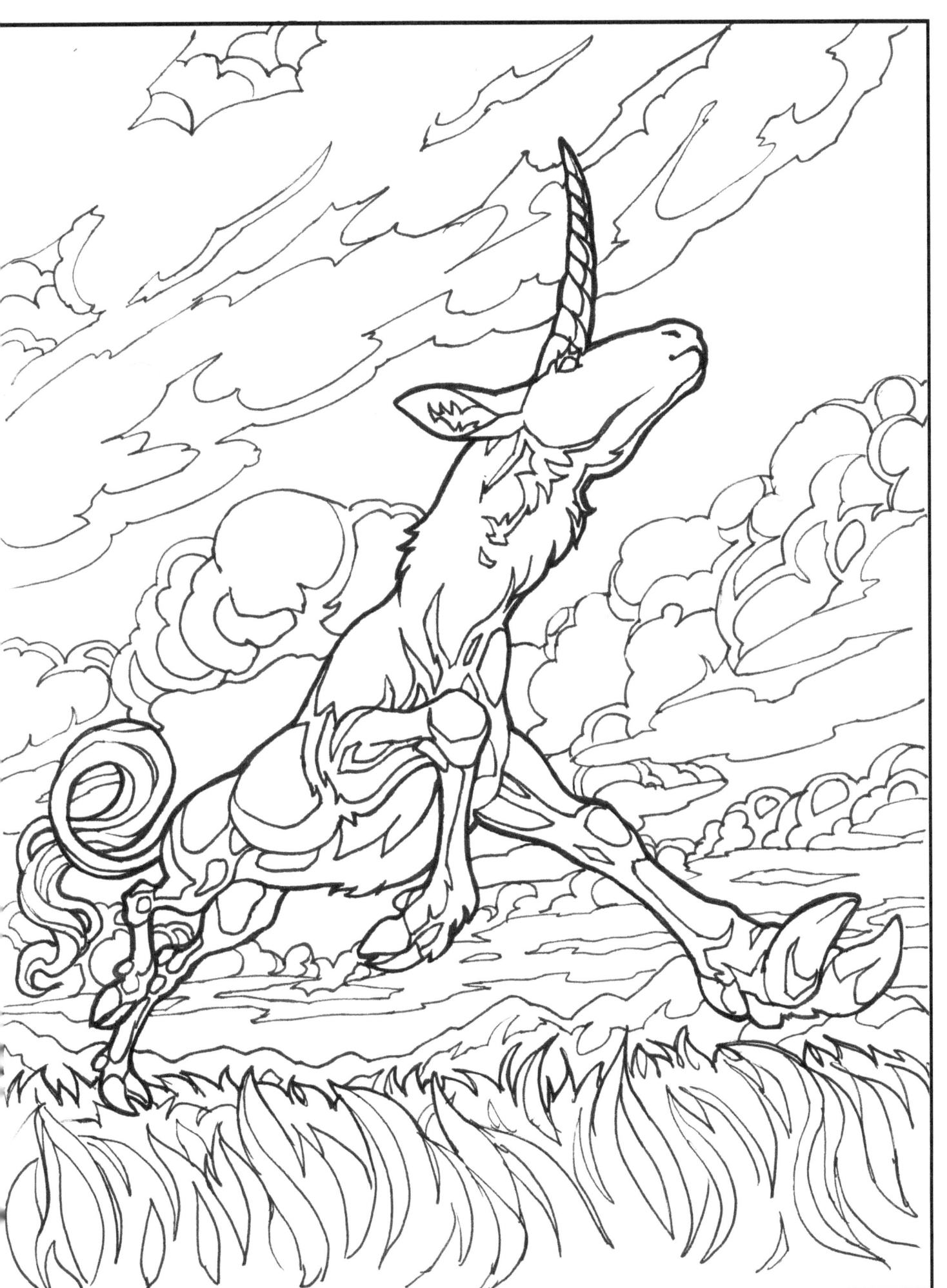

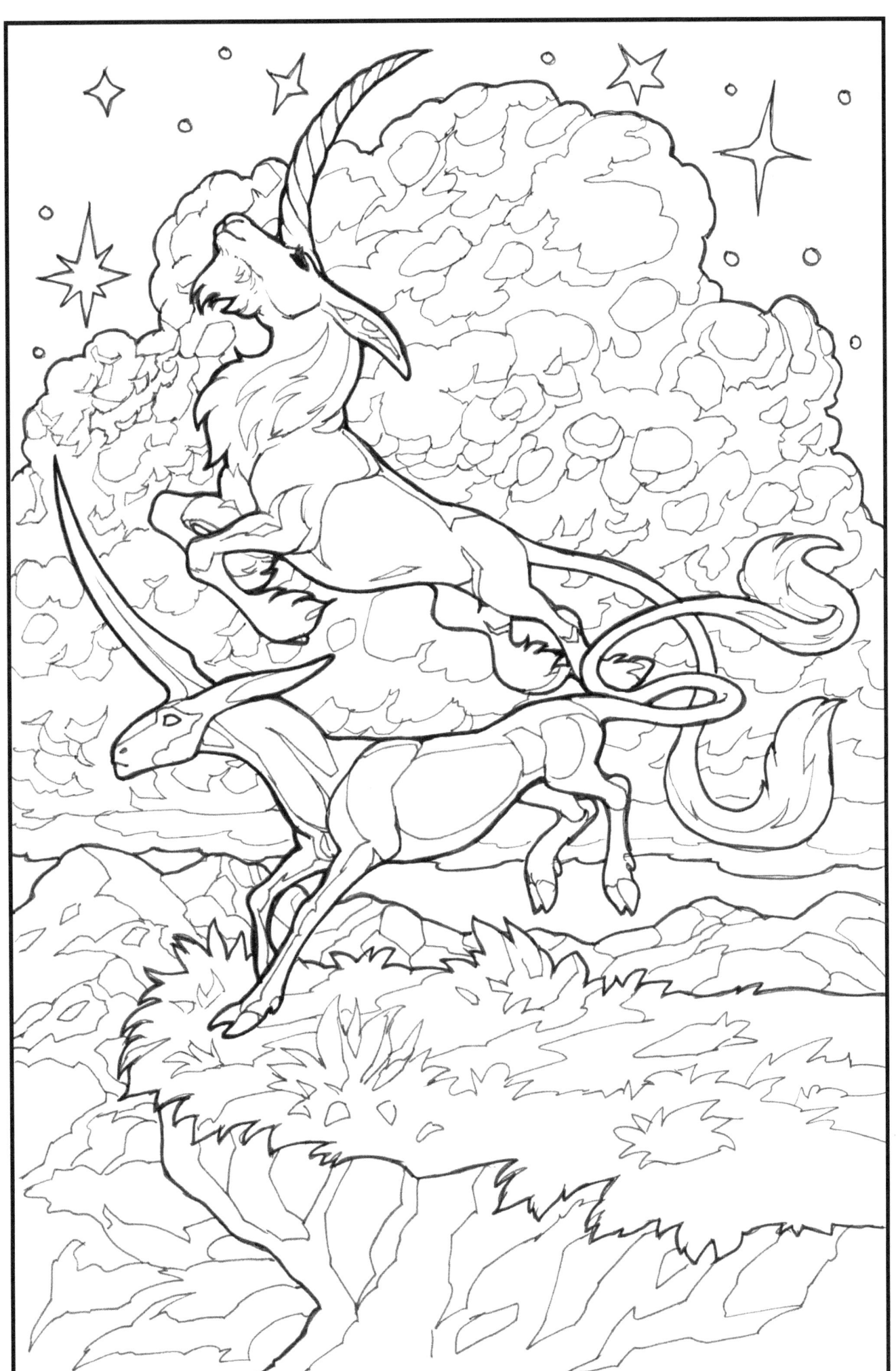

~ Color Test Page ~

~ Color Test Page ~

~ Color Test Page ~

Thank you!

If you enjoy this book, please leave a review on Amazon so that more people can find it!

Contact and Social Media:

E-mail: blakedowning@outlook.com
Tumblr: blakealexanderdowning.tumblr.com
Facebook: facebook.com/blakealexanderdowning
Twitter: twitter.com/BlakeAlexanderD
Instagram: instagram.com/blakealexanderdowning/

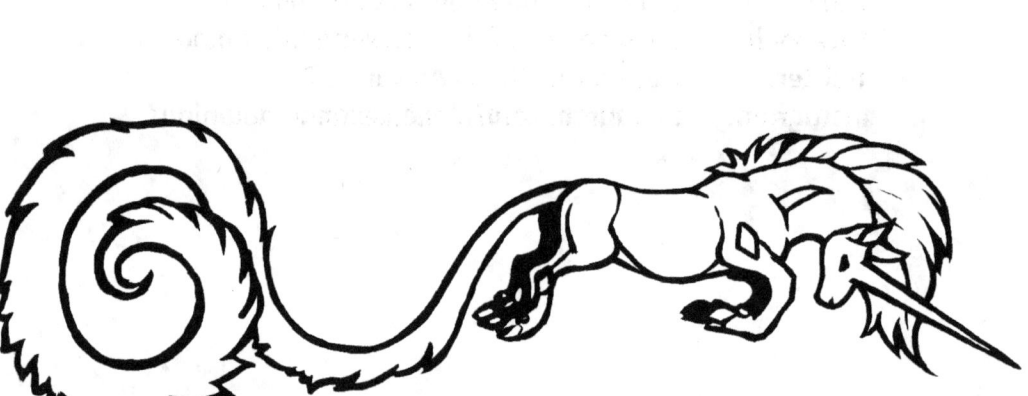

www.ingramcontent.com/pod-product-compliance
Lightning Source LLC
Chambersburg PA
CBHW060000230526
45472CB00008B/1881